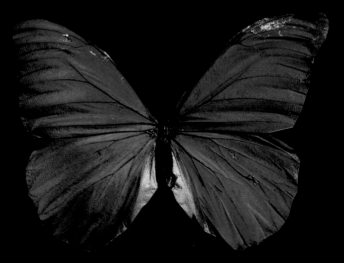

The beauty and genius of a work of art may be

reconceived, though its first material expression be

destroyed; a vanished harmony may yet again inspire the

composer; but when the last individual of a race of living

things breathes no more, another heaven and another earth

must pass before such a one can be again.

—William Beebe

I LOVE NATURE MORE

ROBERT VAVRA

William Morrow and Company, Inc.
New York

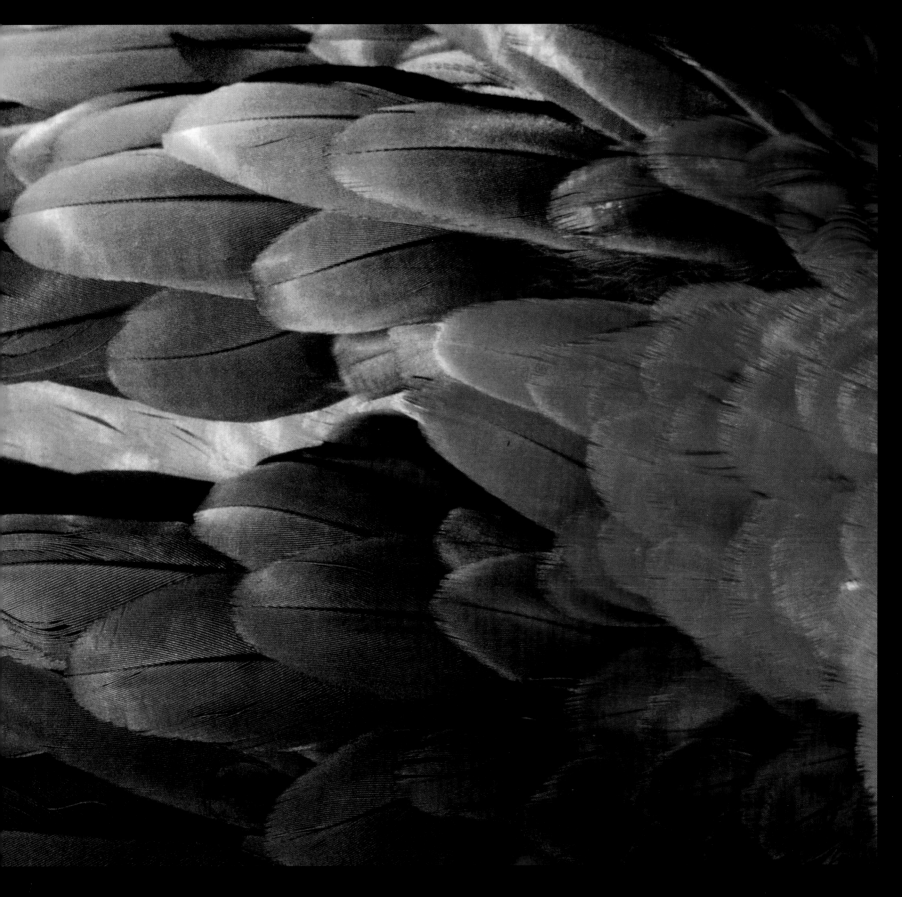

For Ron and Gale with Love

Library of Congress Cataloging-in-Publication Data

Vavra, Robert.
 I love nature more / Robert Vavra.
 p. cm.
 ISBN 0-688-06851-0
 1. Natural history—Kenya. 2. Nature photography. I. Title.
QH195.K4V38 1990
508.6762—dc20

First Edition

1 2 3 4 5 6 7 8 9 10

Printed and bound in Spain by Cayfosa
Photographic laboratory associate, Rick Fabares
Field production manager, David Kader
Drawings by John Fulton
Design by the author

REFLECTIONS

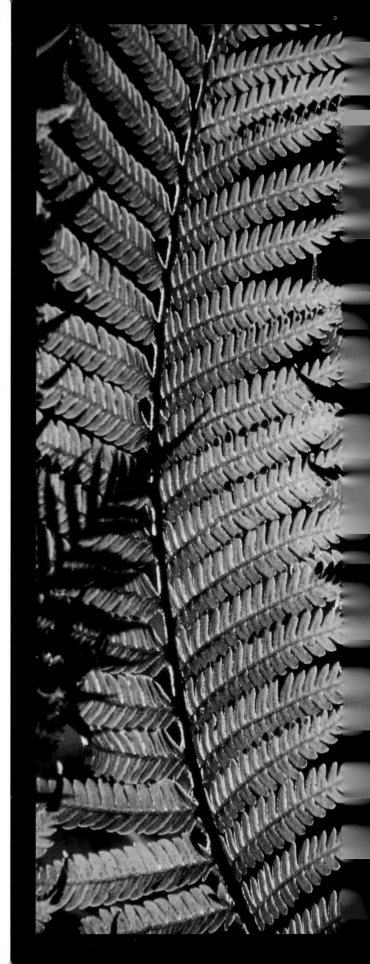

AR below on the ground, umbrella acacia trees clutched together in ever-tightening designs as the aircraft gained altitude. Down there was Kenya. Once clouds had curtained the window view, I settled back in a seat and voiced silent thanks to Africa—that is, to nature. The same nature that fifty-four years ago had given me birth, had during the past five weeks again brought me back to life. Almost a quarter of a century of a self-imposed book-a-year schedule, together with the recent death of whom I loved most, had left me depleted and illusionless. Five weeks at an isolated camp in the Kenyan highlands with two horses and five Maasai friends, surrounded by the Eden of plant and animal life that is still much of East Africa, had provided a seemingly unattainable tonic for the revival of both my spirit and body.

During more than a month, not another white face—except my own in a cracked mirror—had darkened the camp which was in the hills that rise to the east above Maasai Mara. There I had been gifted with an opportunity that few men enjoy, to live out, in middle age, childhood fantasies. Our days had no plan. There was no cardboard, familiar conversation; the only words that reached my ears came from Maasai lips. We kept no schedule, had no routine except that which nature imposed on us for eating and sleeping. My friend Sekerot Ole Mpetti, who had made the adventure possible, and I roamed the hills on foot or on horseback, light-years away from anything that could be contaminated by the word *civilization*.

With a rather ineffective, homemade butterfly net, I spent many mornings alone exploring below our camp the glades and streambed whose course could be traced by the emerald vegetation that umbrellaed up from it, twisting toward the Mara. Lion, elephant, leopard, Cape buffalo, cobra, mamba, and viper lived where we did.

A snapped twig or swish movement through the grass at first startled my heart into seemingly audible beats of fear. However, after a week, this terror was mostly, but not always, replaced by cool apprehension. As I became more a part of Africa, a new-found serenity allowed my eyes and ears to focus—apart from on possible danger—on the natural beauty that was everywhere. Admittedly, it was at first unsettling to walk alone a mile downstream hunting butterflies, to return hours later and encounter lion or leopard spoor over my own. But I learned from Maasai friends Sekerot, Morkau, Lepish, Sicona, and Moseka, that as long as I was awake to the mostly unseen but real dangers of the bush, I could enjoy the African gallery of design and color that continually tantalized and seduced my eyes.

(Continued on page 66)

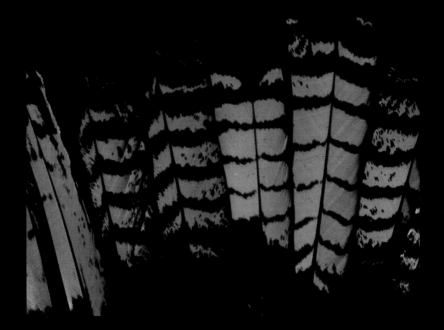

LOVE NATURE MORE

The full-color capital letter that heads each column of text on each page in this book is a magnified section of a butterfly or moth wing. Photographed from Africa to the Andes, these insect wings provided all twenty-six letters of the alphabet.

erfect?

Pure?

Man

has not

a single

word

to describe

what

nature created

with

my invention.
—Song of the Nautilus

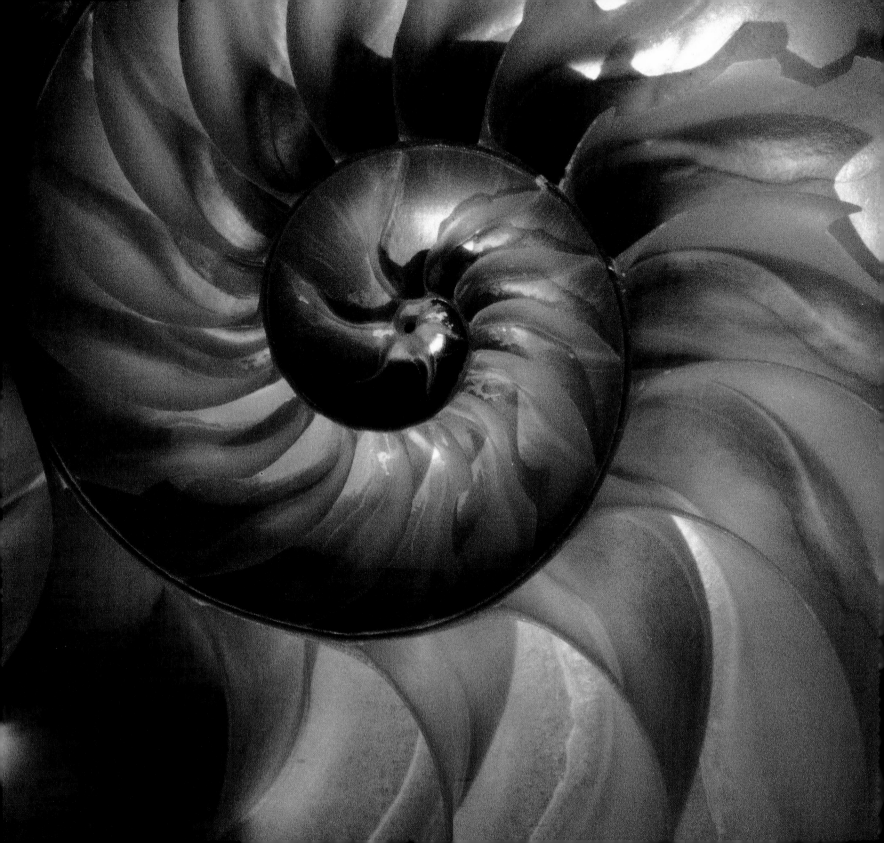

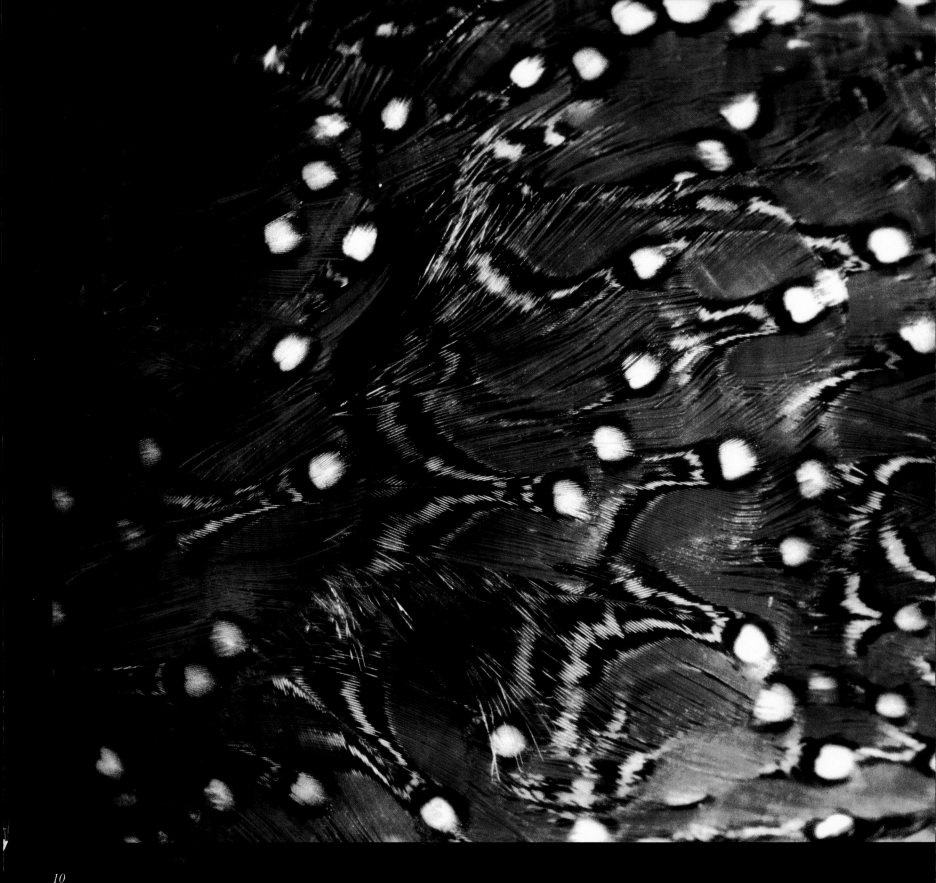

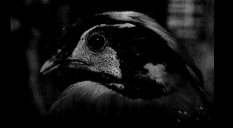

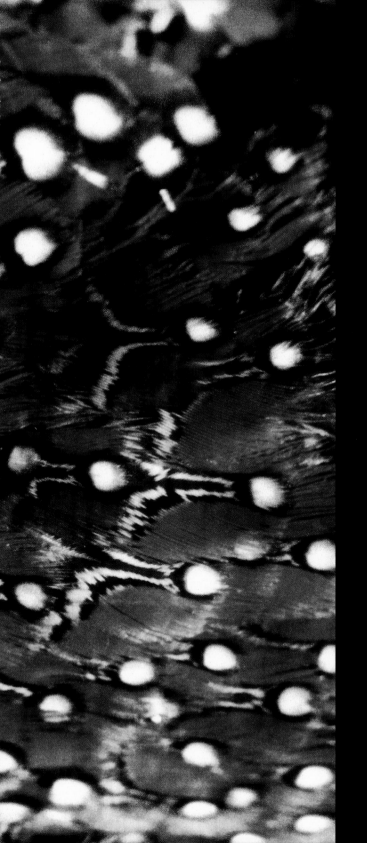

onely

snow

falls

on the sunset

of

my being.

Surprise!

I

appear

before thee.
—The Temminick's Tragopan's Song

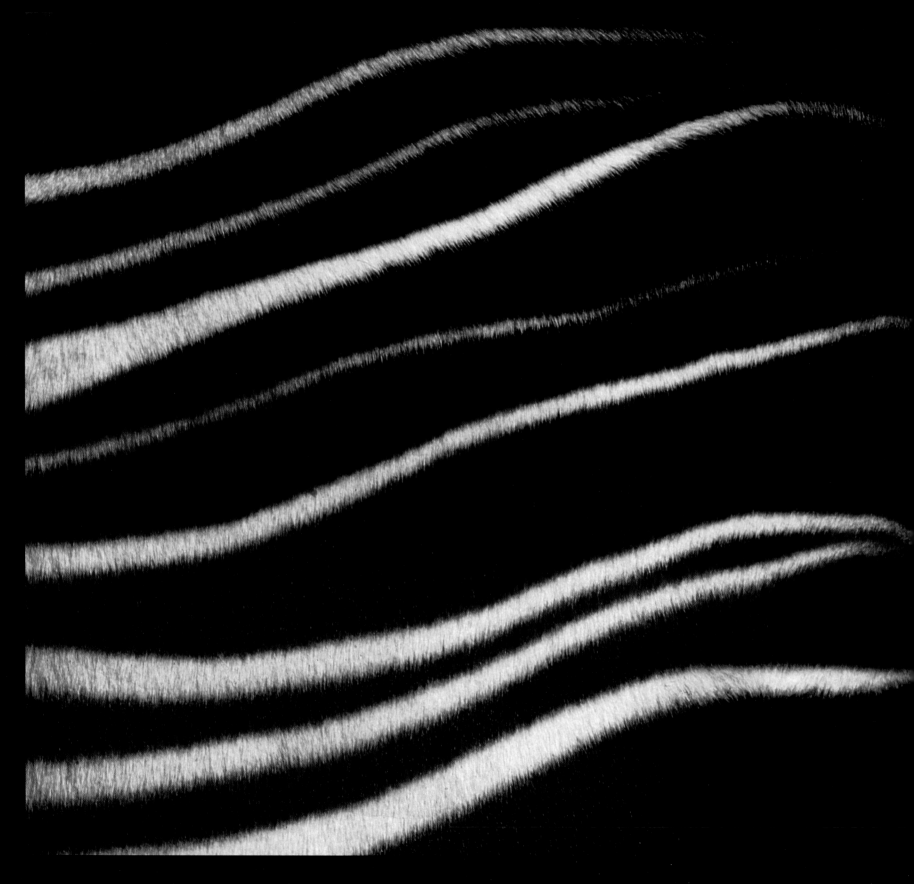

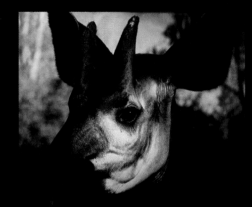

hat man

could slay

a thing so

gentle,

so shy,

so unready

to die,

reveals

where

the true beast

lies.
—The Okapi's Song

merald,

cobalt,

turquoise

flow molten

in the depths

of my

pearl essence

mystery,

which

though

a thousand miles

from water,

still

echoes with

the ocean's roar.
—The Song of the Abalone

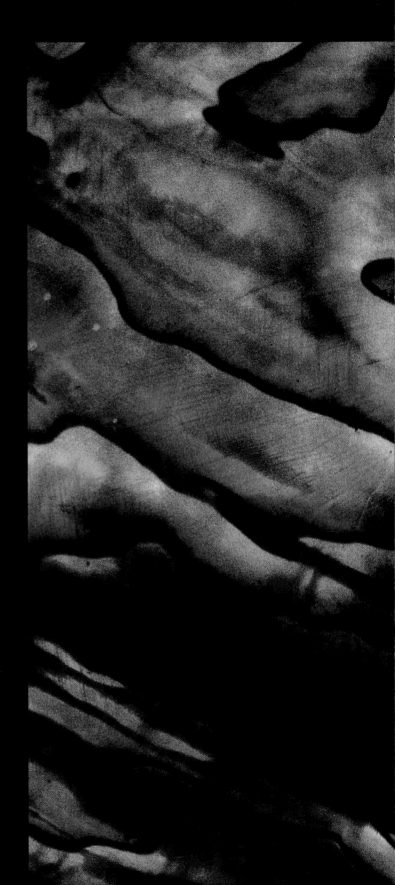

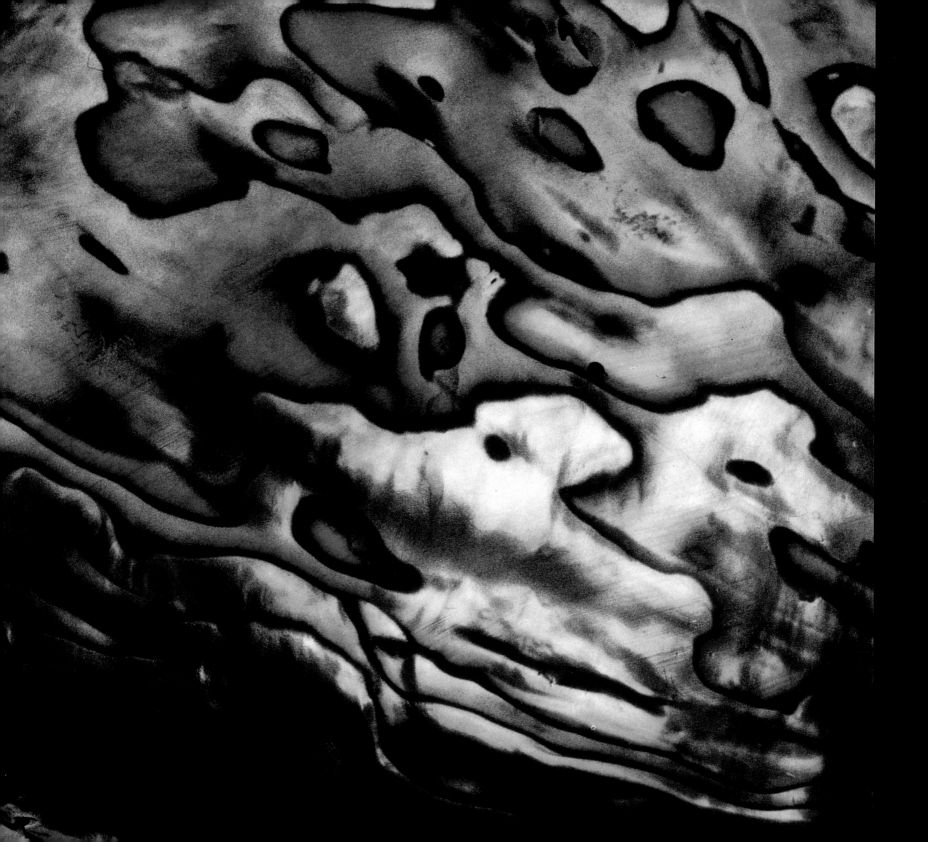

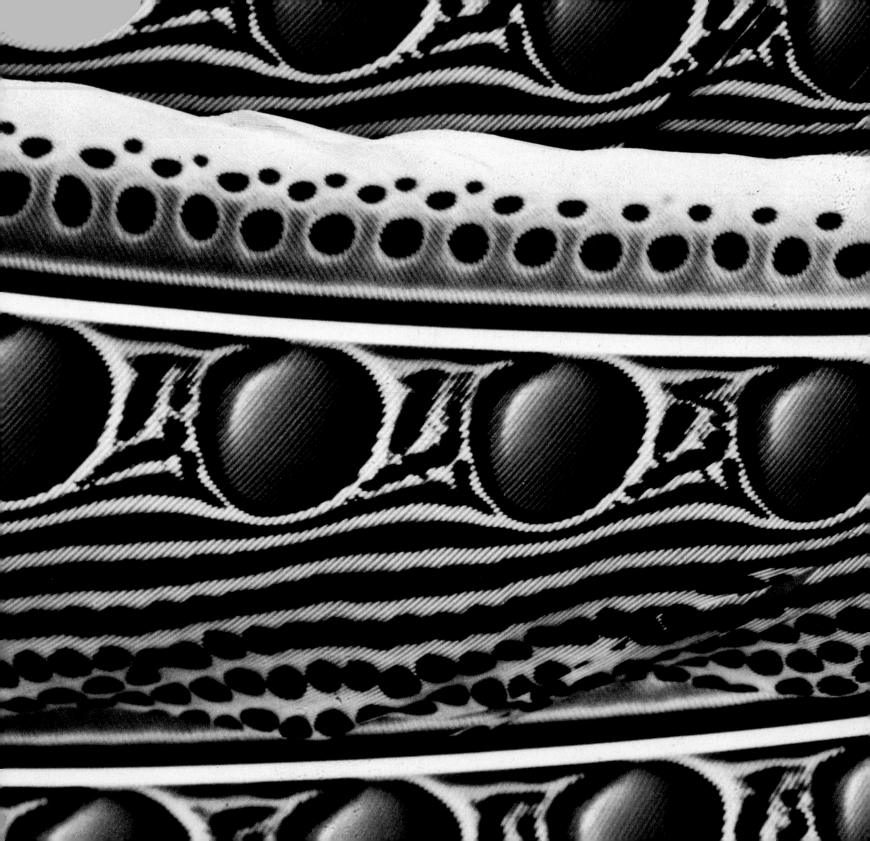

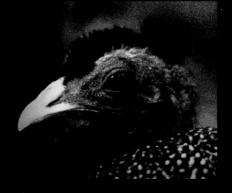

rgus'

fame

proclaimed

my name.

With eyes

as many,

with eyes

as bold,

their hypnotic

power

my mate to hold.

—Song of the Argus Pheasant

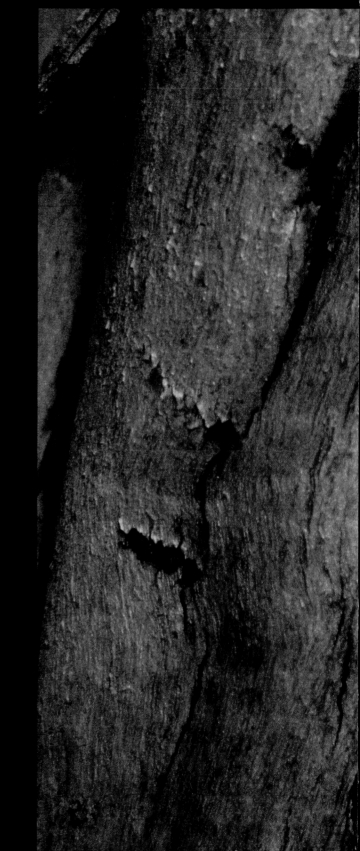

own under

a tree

is

a tree

is

a tree.

But

no other

perfumes

the air

like me.
—Song of the Eucalyptus

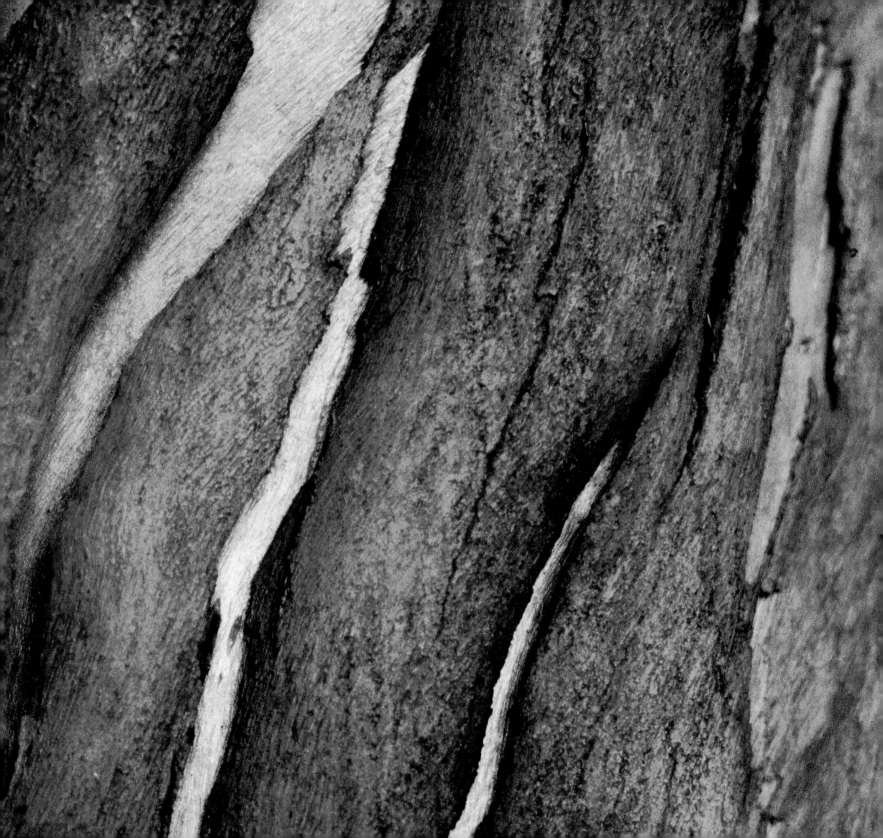

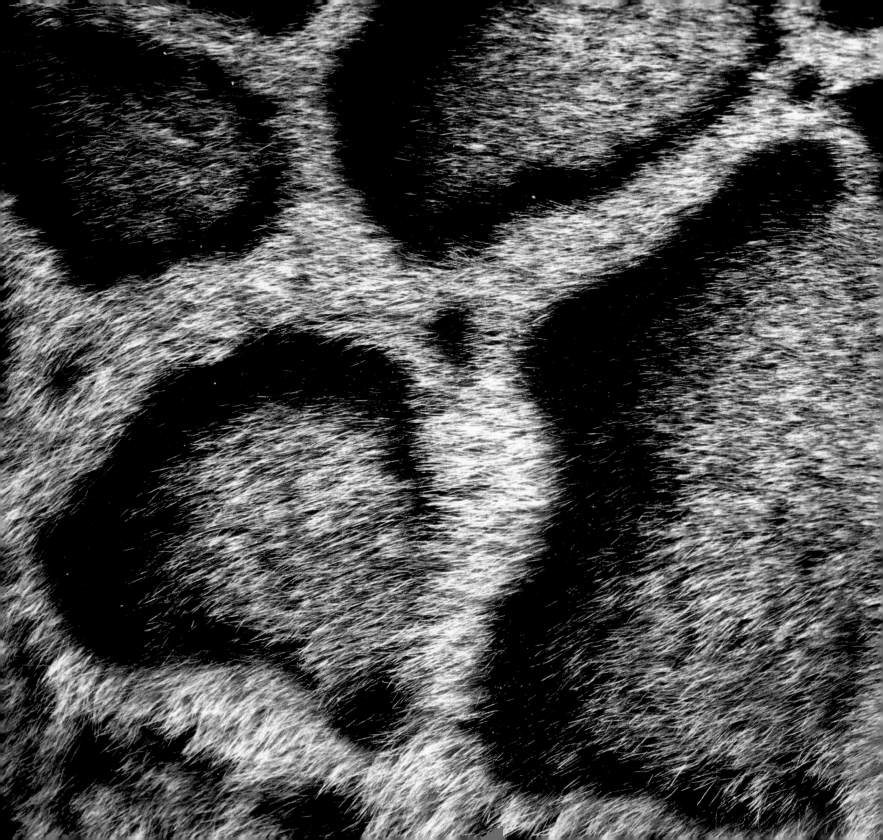

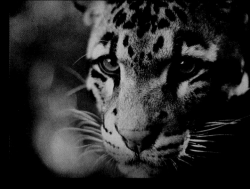

eils of mist

descend

the trees,

no more silent

than I.

Beware

below

deadly cumulus

has settled on

a branch.

—The Clouded Leopard's Song

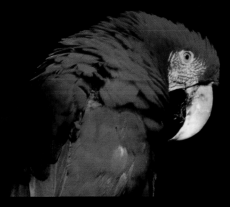

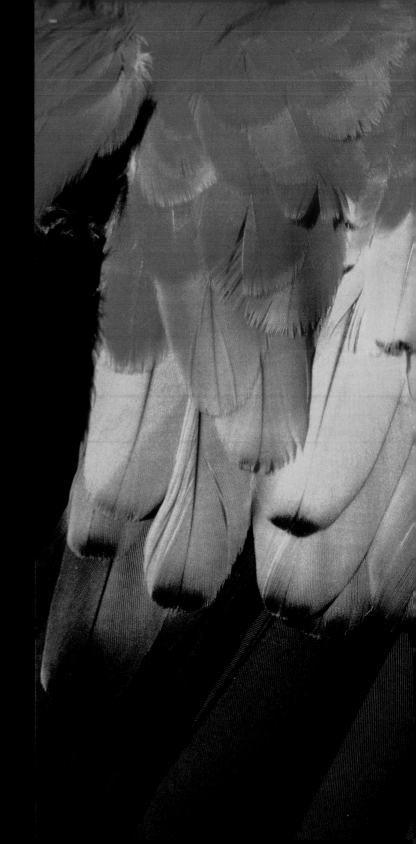

onkeys

howl.

Parrots

scream.

I'm the

rainbow

bird

of an

Incan dream.
—The Macaw's Song

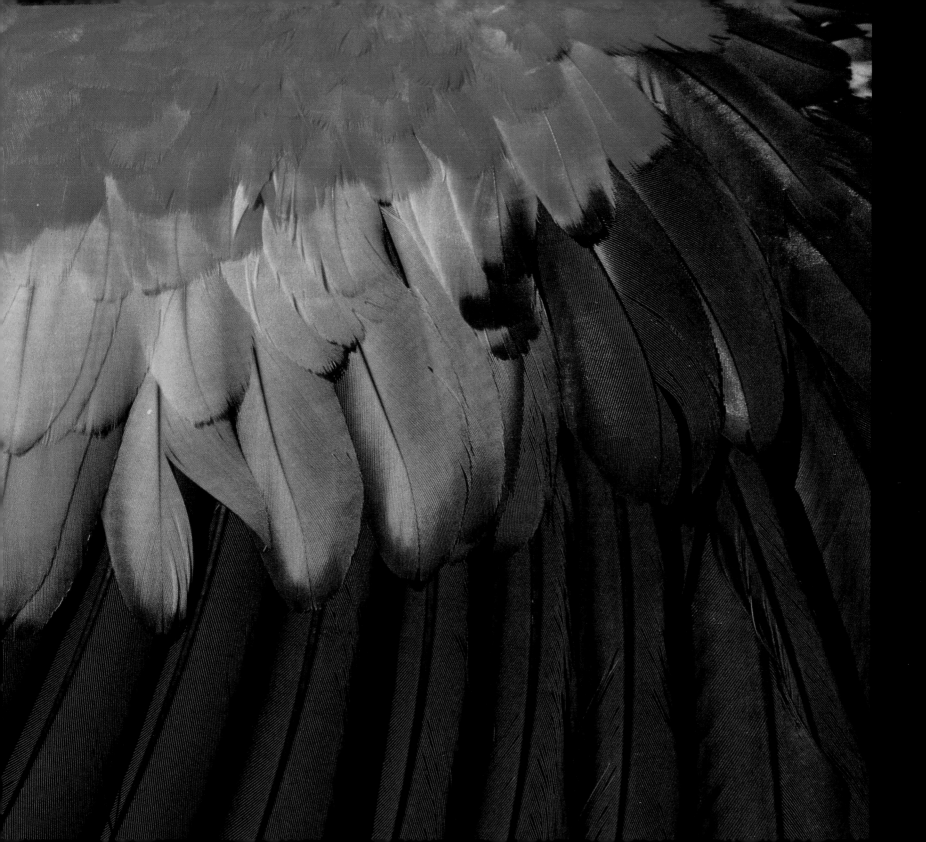

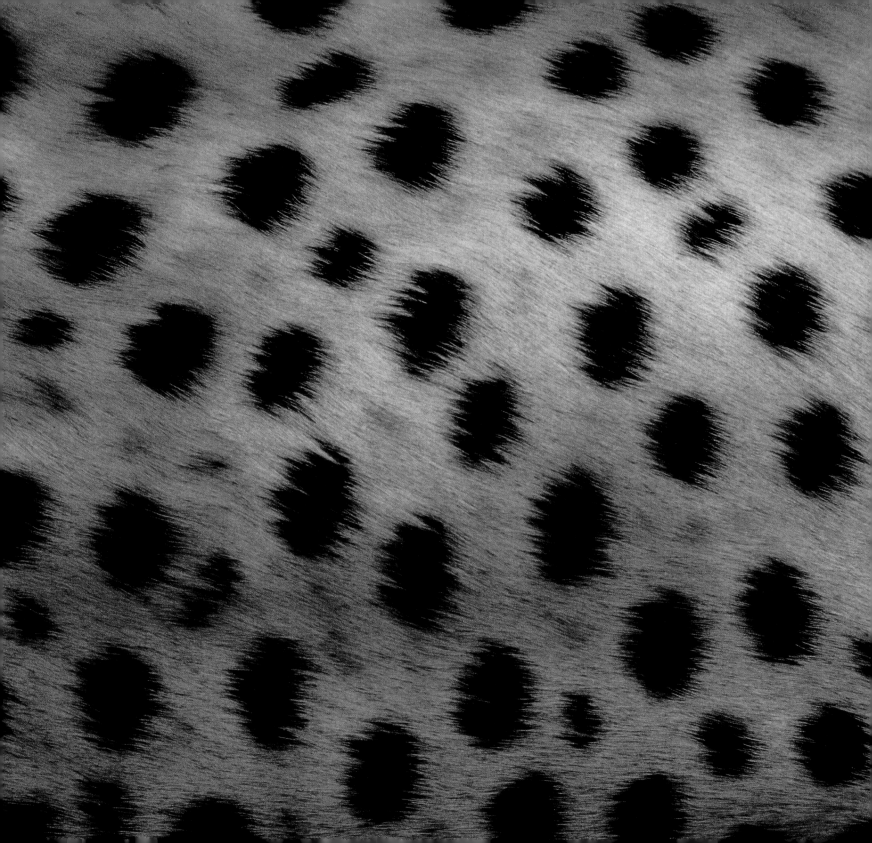

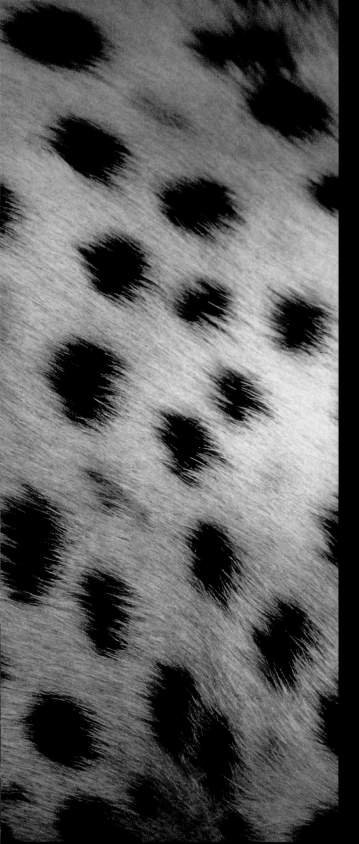

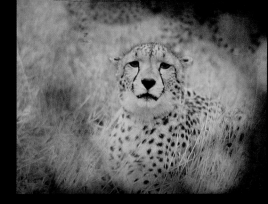

olden as August grass.

Swift as winter wind

through Serengeti grass.

Teeth as sharp as

marsh grass.

Gentle as April grass.

Oh,

how I like

to

lie

in the grass.

—The Cheetah's Song

ungle

footsteps

swish closer,

tap closer,

drum closer

through

the glade

swaying

as they pass

my pachyderm

ears

of green.
—The Philodendron's Song

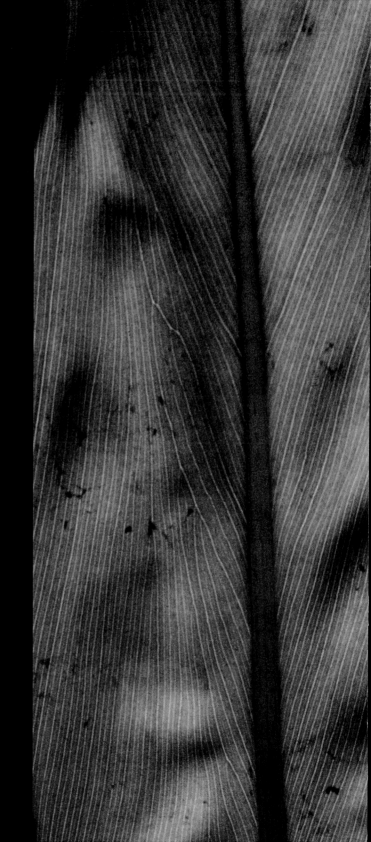

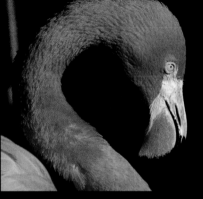

odiacal glow

illuminates

the darkening sky

as sunset's last petals

descend

to

one-legged

stand

in the company

of our own

reflections.

—The Flamingos' Song

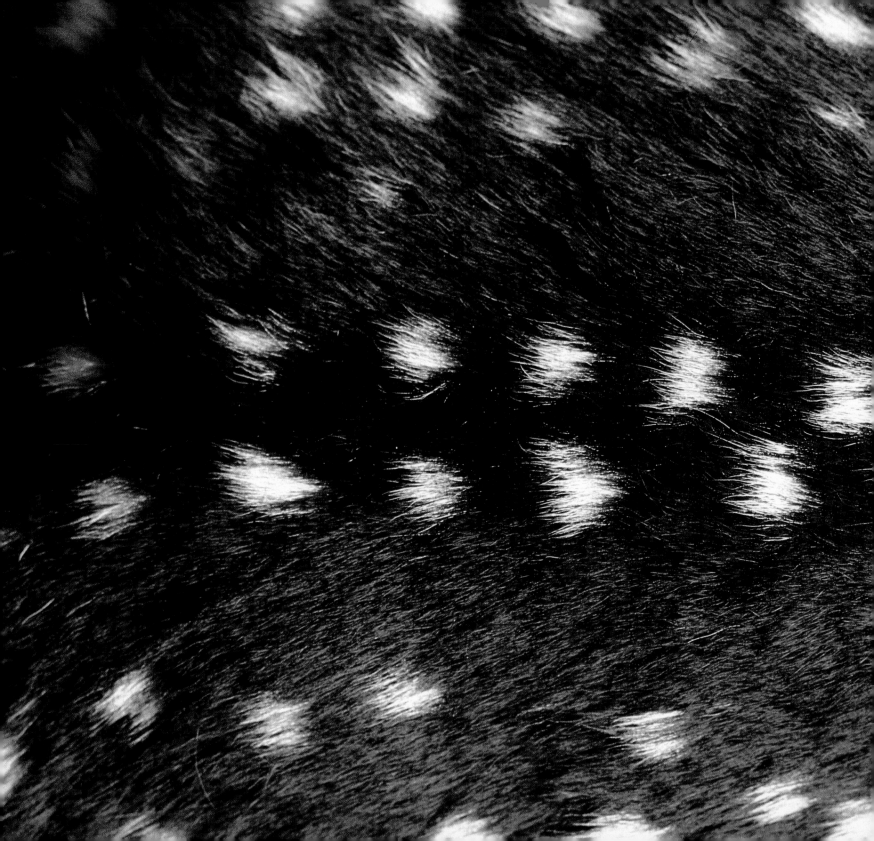

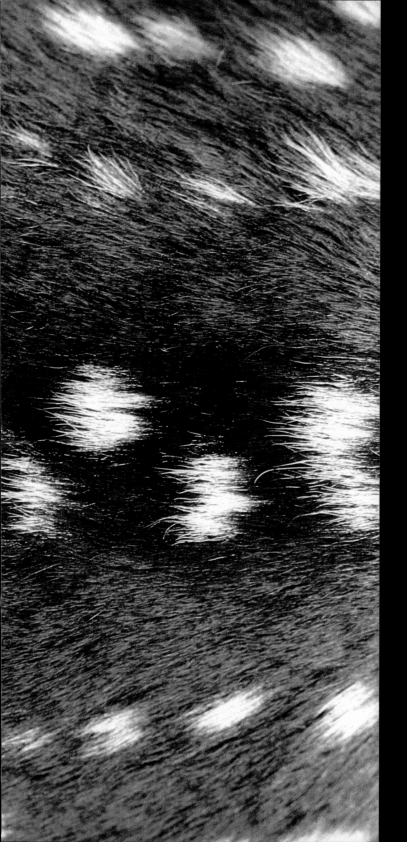

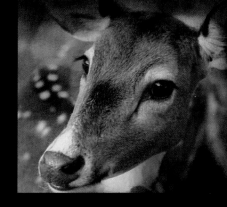

ould these

fawn

spots

that did

not disappear,

star forever

my existence

in a coat

of eternal

youth?
—Song of the Sika Deer

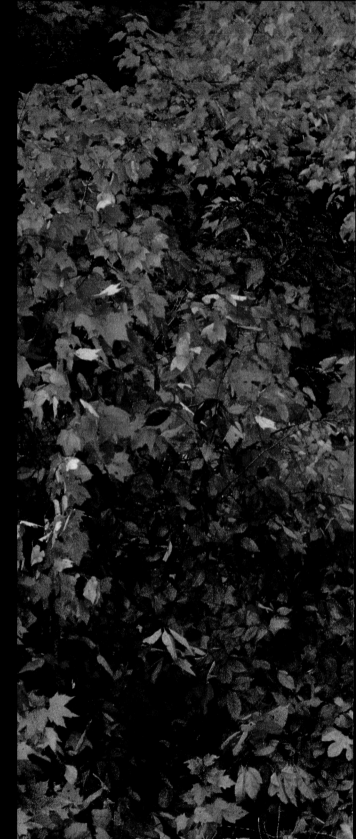

oiseless

November forest fire

whose icy flame

retreats as

quickly as

it advanced

to ignite the ground,

and

leave us

leafless,

stark

and

bare

as would have

any August blaze.
—Song of the Fall Woods

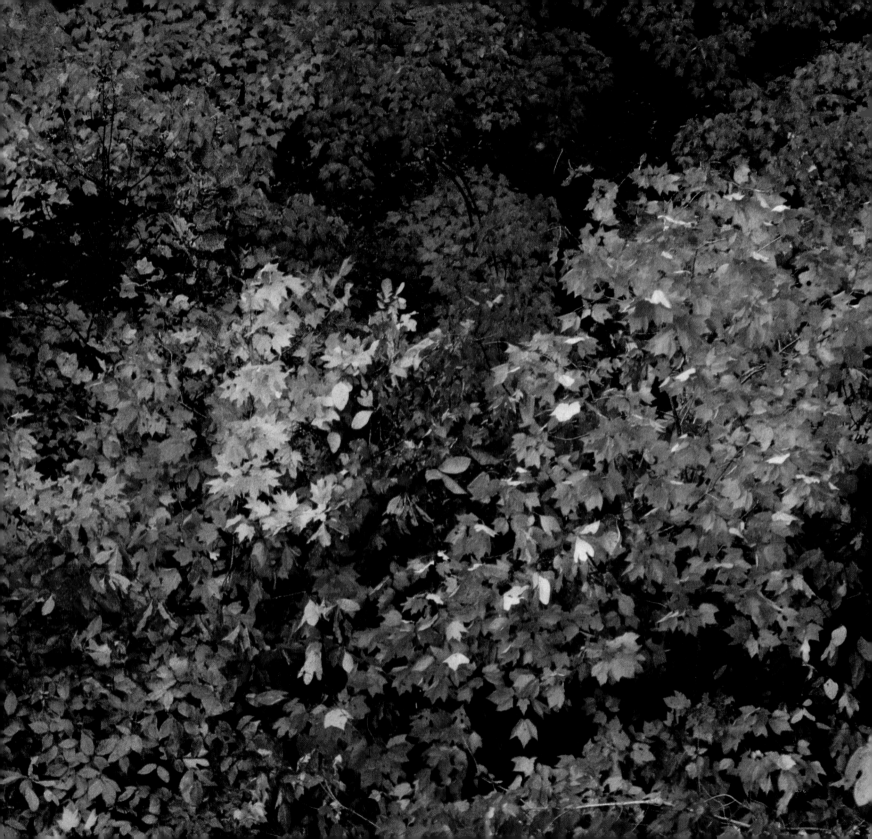

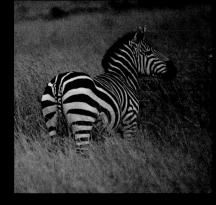

orses

of

Africa.

African

horses.

Striped with

ebony

and

the snows

of

Kilimanjaro.
—The Zebra's Song

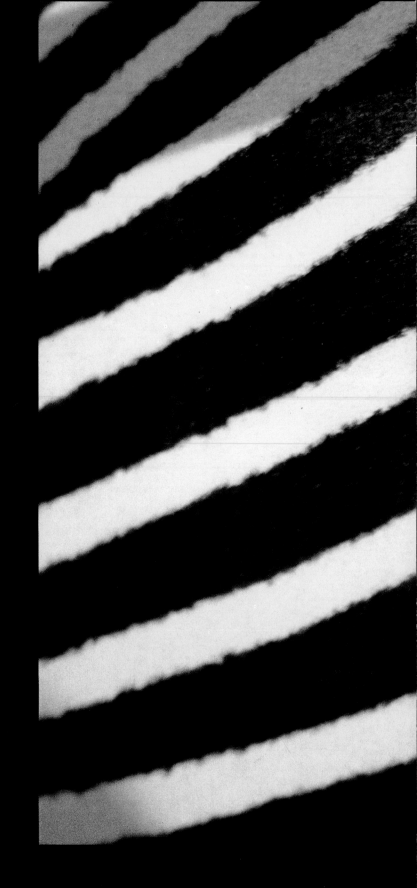

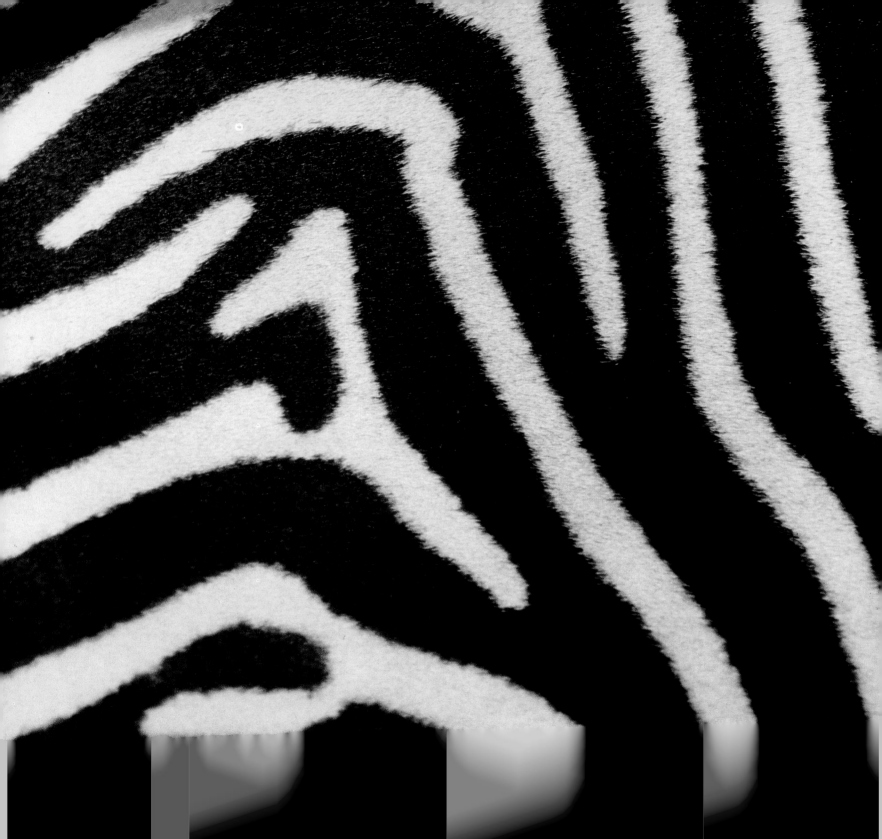

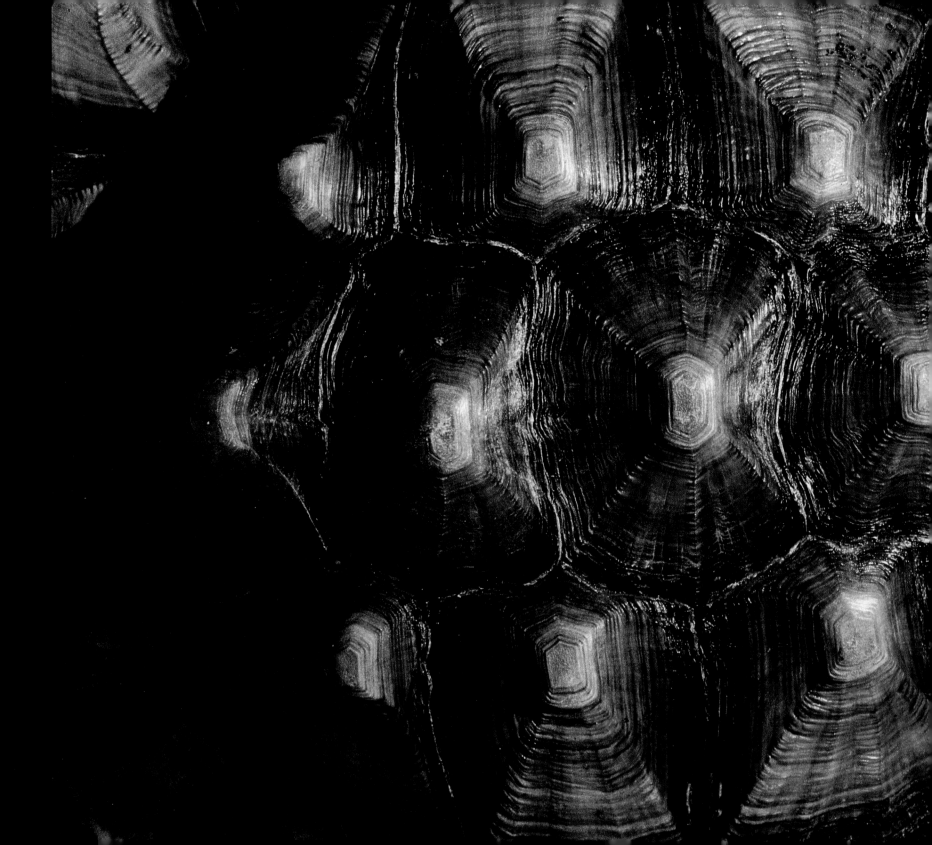

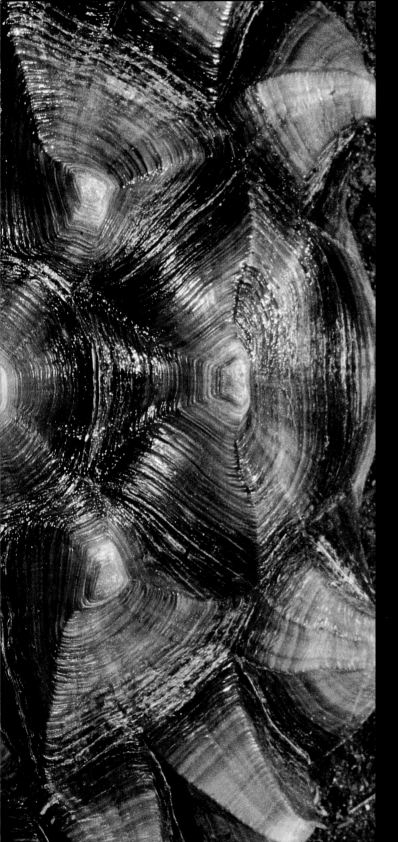

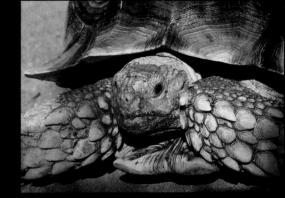

orget not!

When you think of

things gourmet;

or fashioning

me into

a mandolin.

We be of

one

blood

you and I.

—Song of the Spurred Tortoise

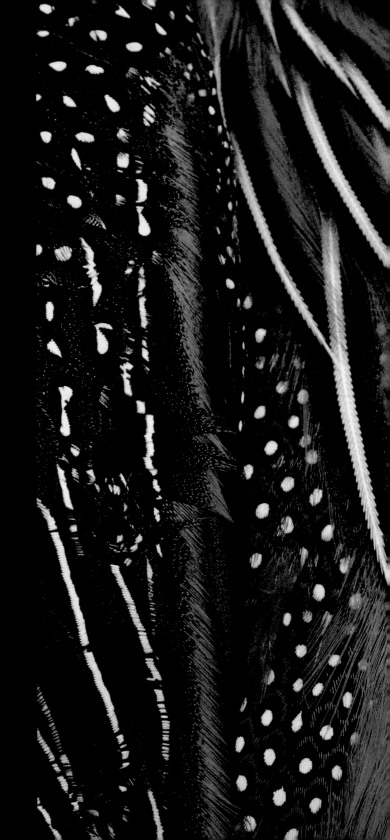

now

slides

the azure current

of these plumes

as we

cackle

and scratch,

under Kilimanjaro

on

the equator.

—Song of the Vulturine Guinea Fowl

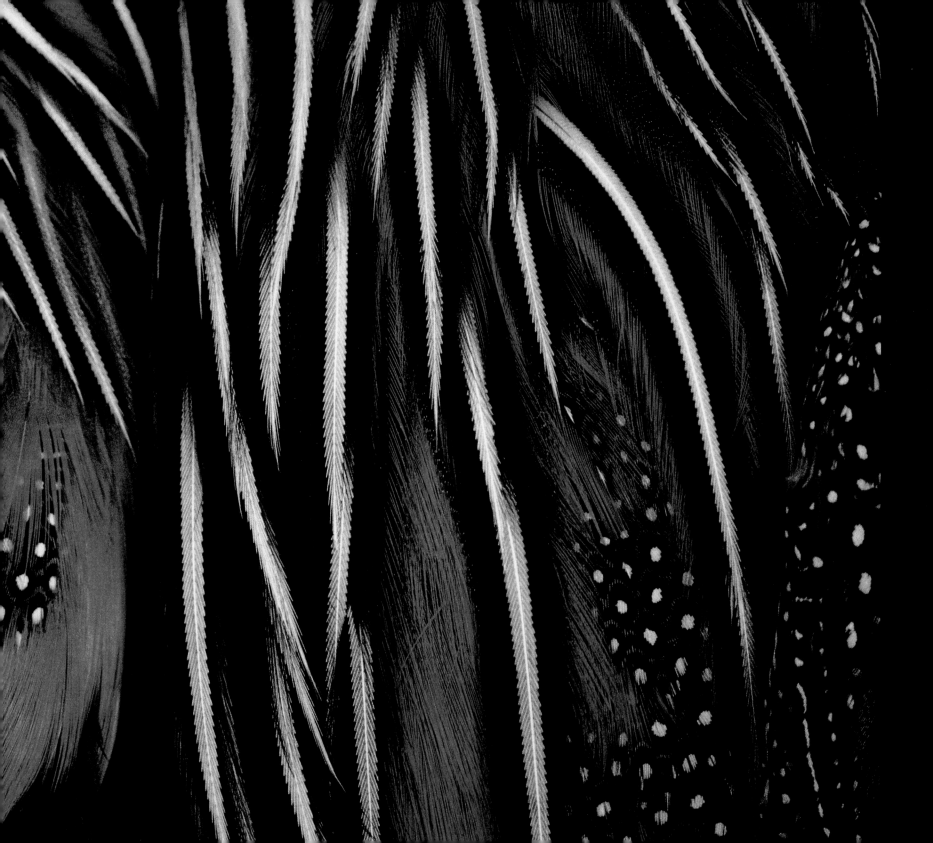

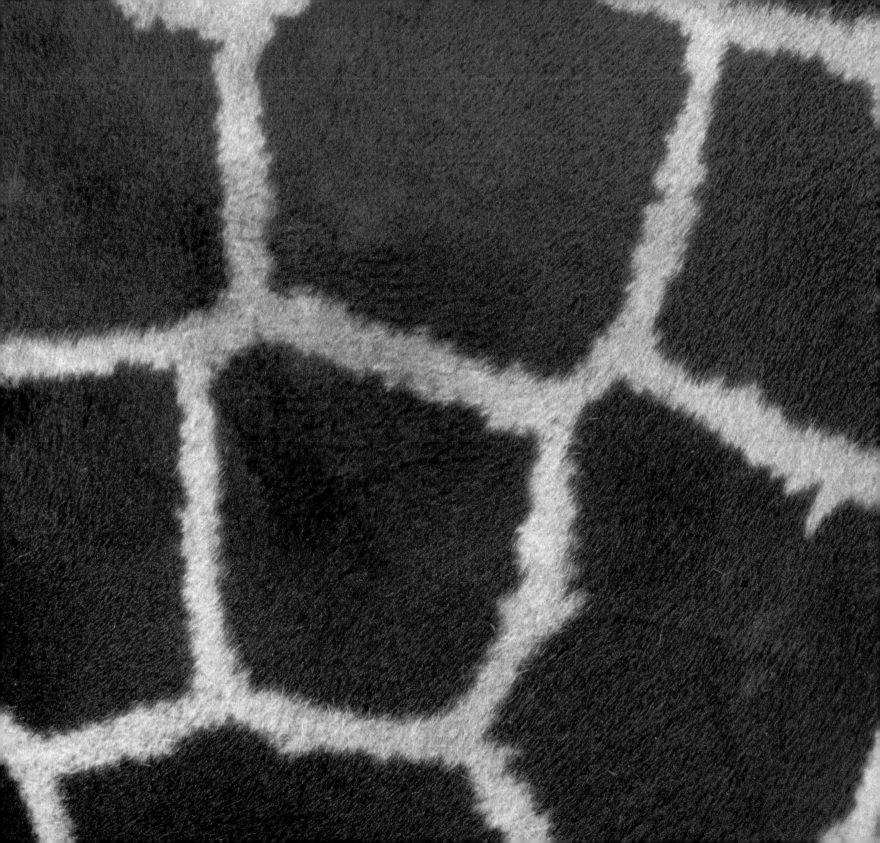

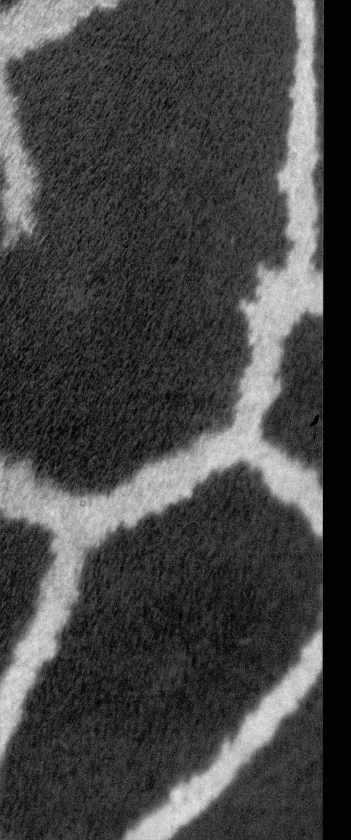

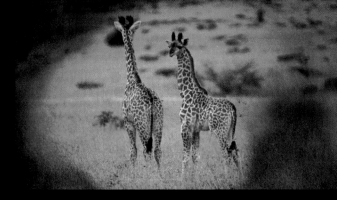

"*Inimitable,*

vegetative

gracefulness . . .

rare,

long-stemmed,

speckled,

gigantic

flowers,

slowly advancing,"

the baroness described us

best.

—The Giraffe's Song

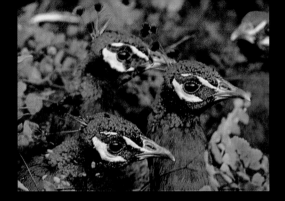

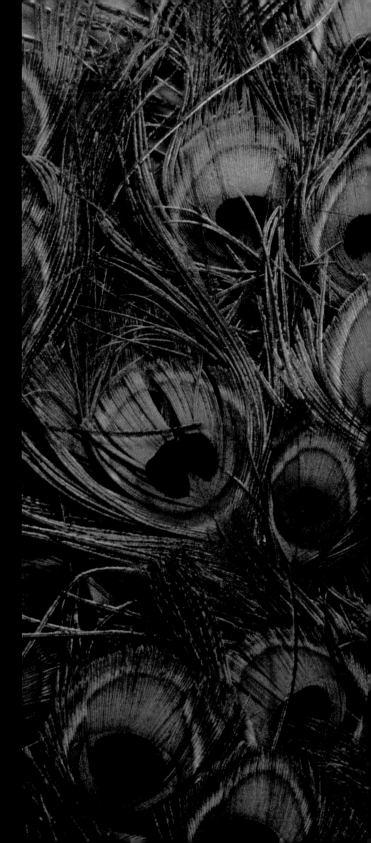

X anadu,

my cry echoes

through your

darkened streets.

Midnight screams

in Rajasthan dreams.

Without my voice

how could the jungle

claim

its name?
—The Peafowl's Song

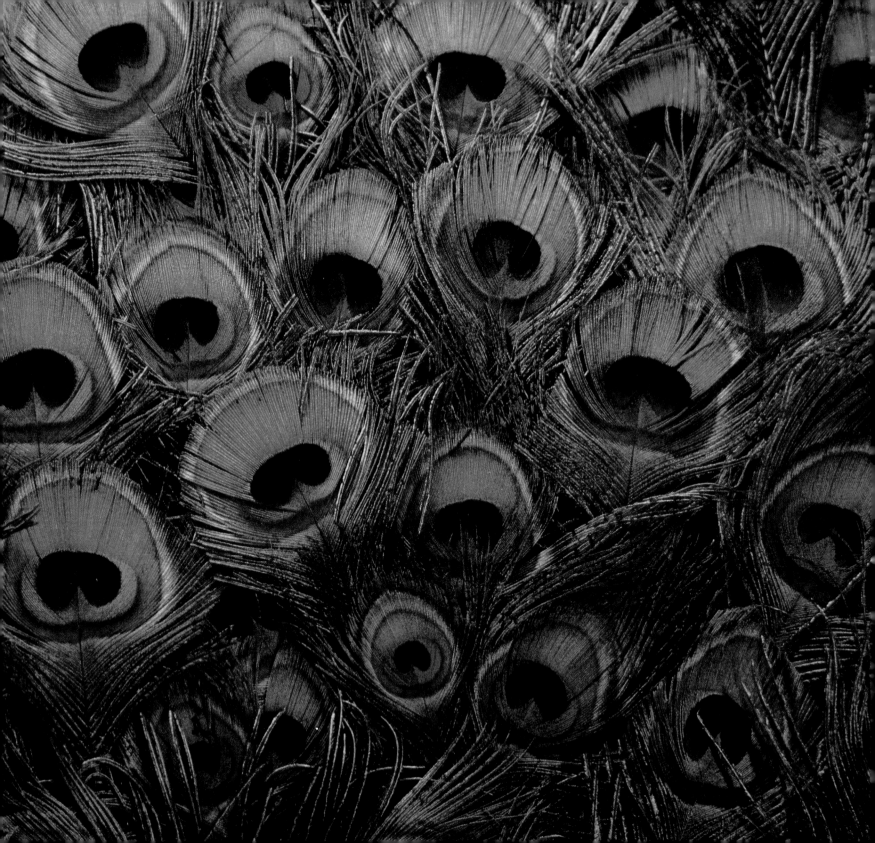

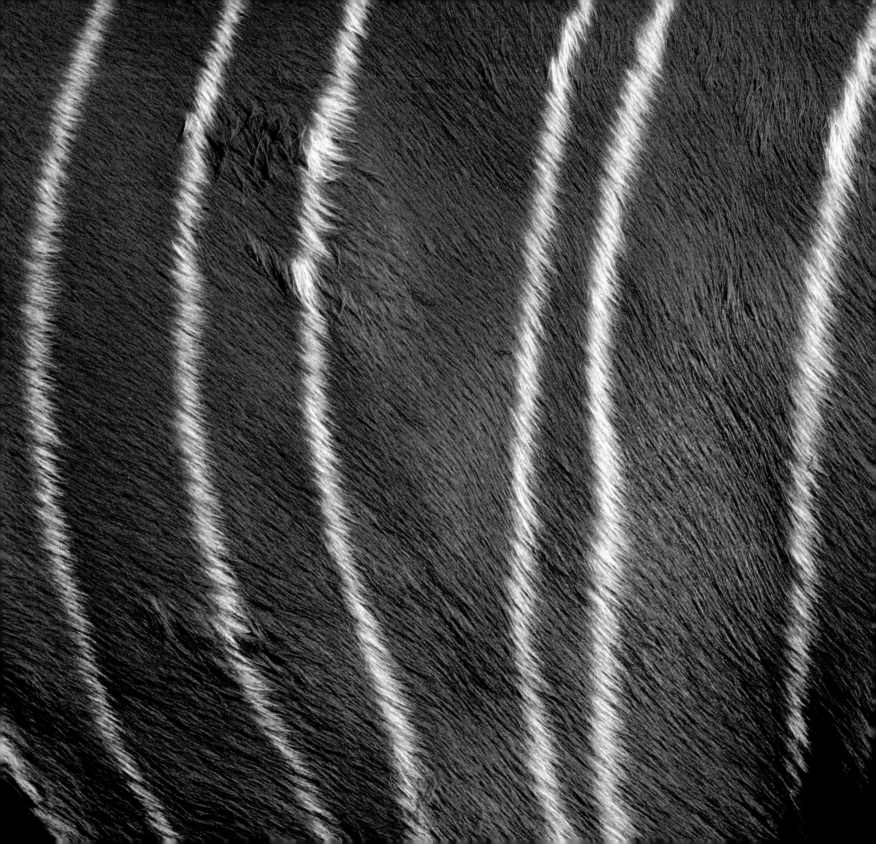

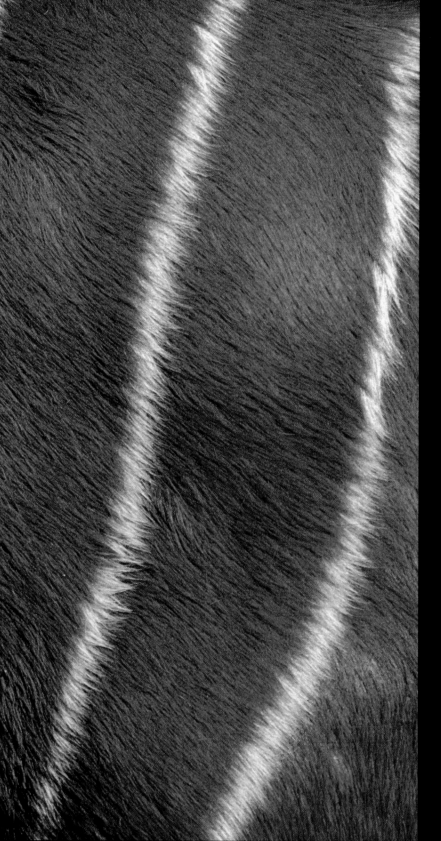

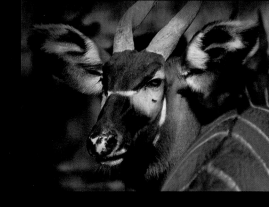

ongo!

Silence—

Bongo!

Silence—

our hearts

throb,

counterpoint

drums in

a stillness

of

eternal green.

—The Bongo's Song

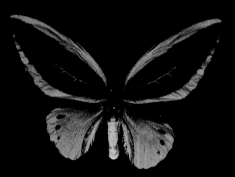

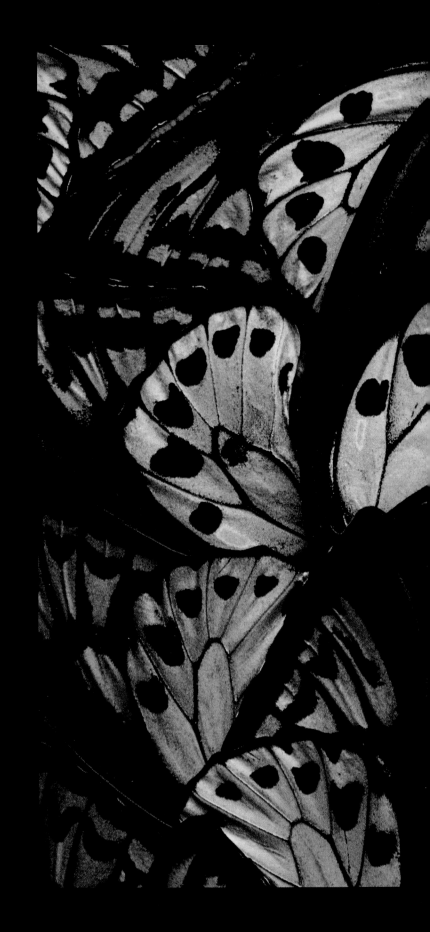

uetzal plumes

nor

queens' heirlooms can

rival our variety

and brilliance.

No

garden petals

set to wing

our

wind-borne

beauty.

—The Birdwing Butterflies' Song

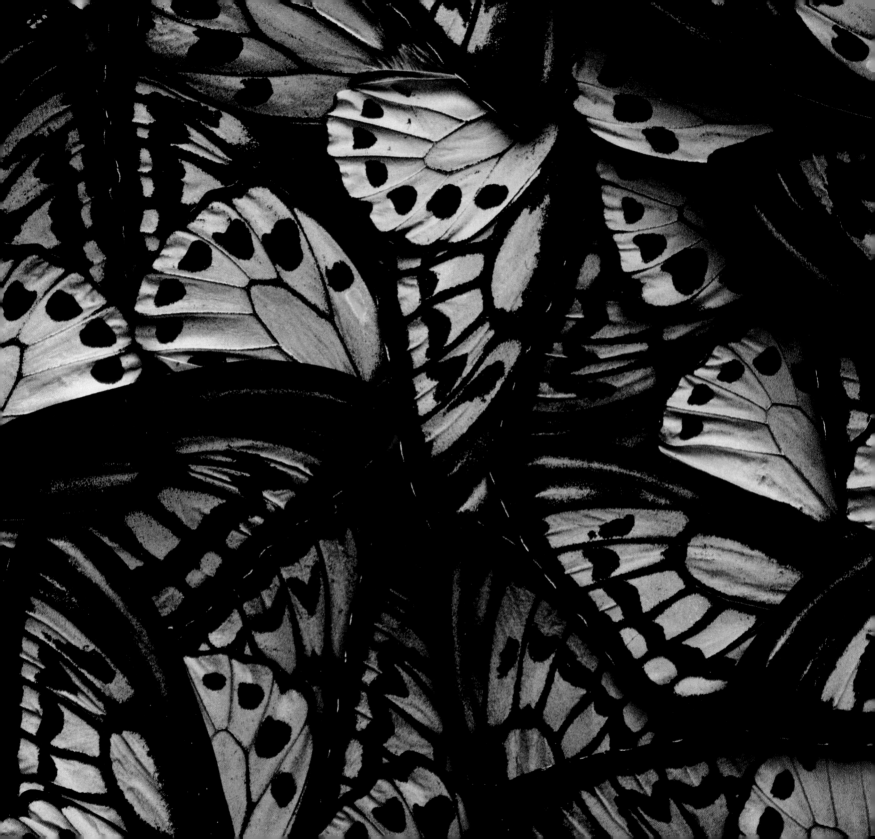

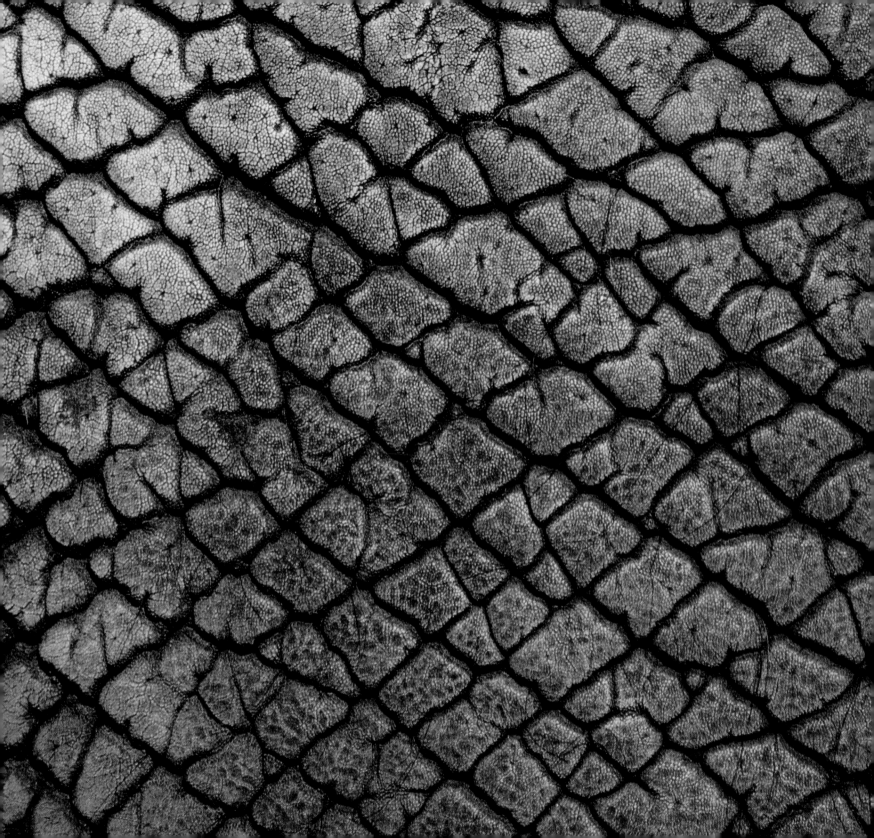

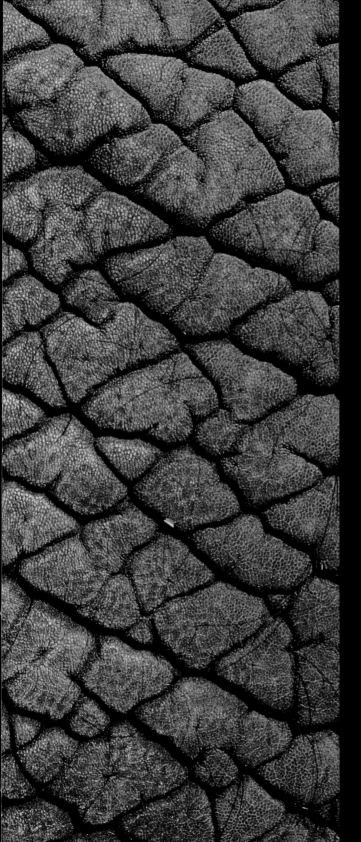

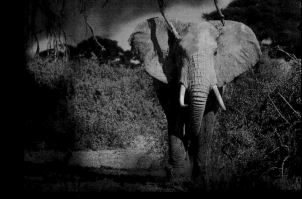

he shark is hunted for

his fin.

The rhino for

his horn.

The tiger for

his stripes.

And me for

ivory worn.

If we are doomed,

what hope

is there for man?

—The African Elephant's Song

e are

one

of

forked tongue,

of

silent, sliding scales.

Fear?

Oh,

what fear

you have of

us.

Kaa's might?

Krite's bite?

We are

one

of forked tongue.
—The Python's Song

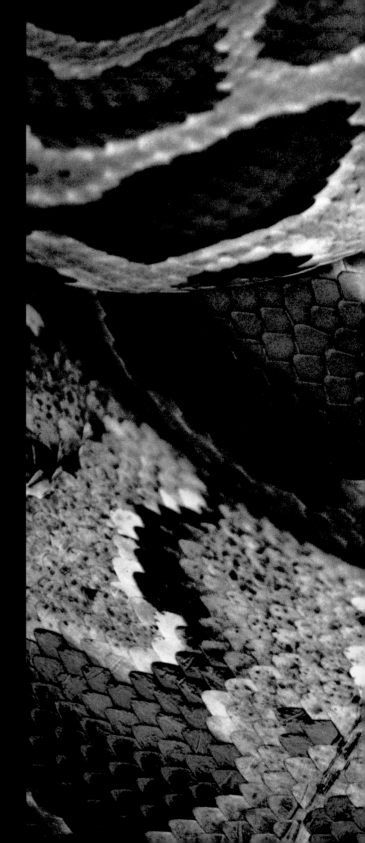

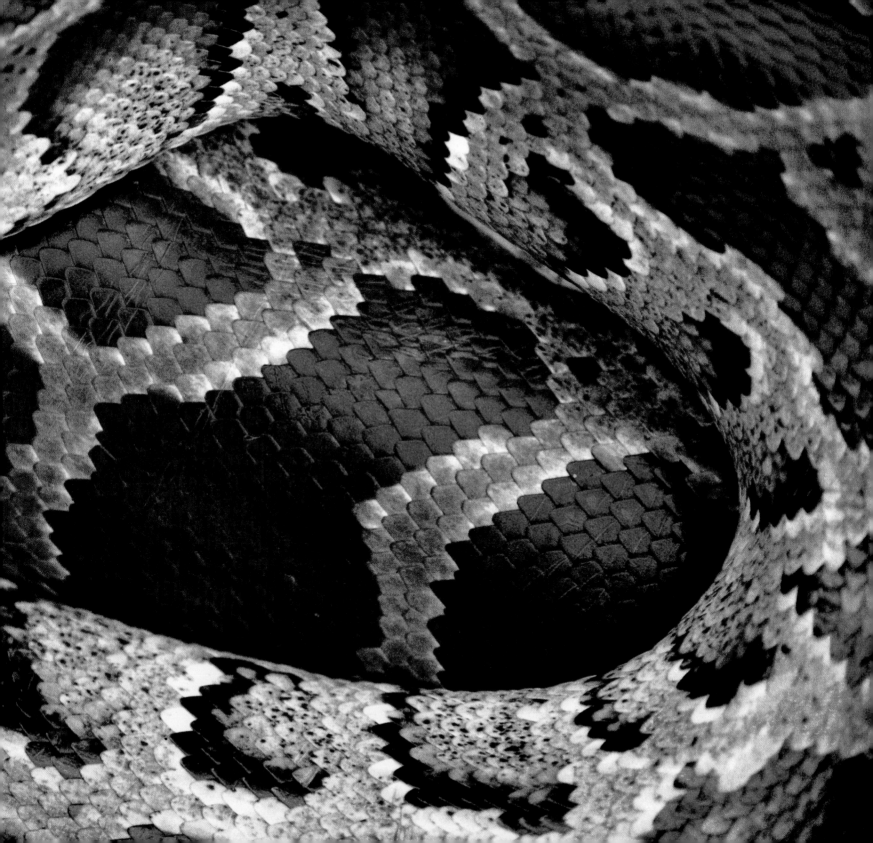

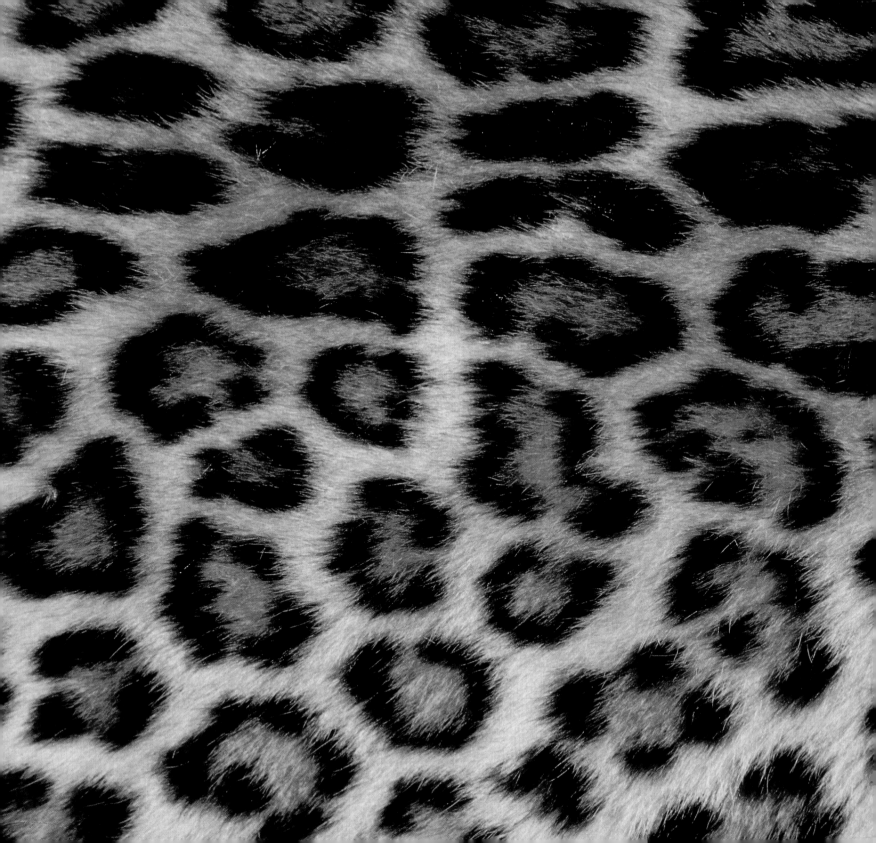

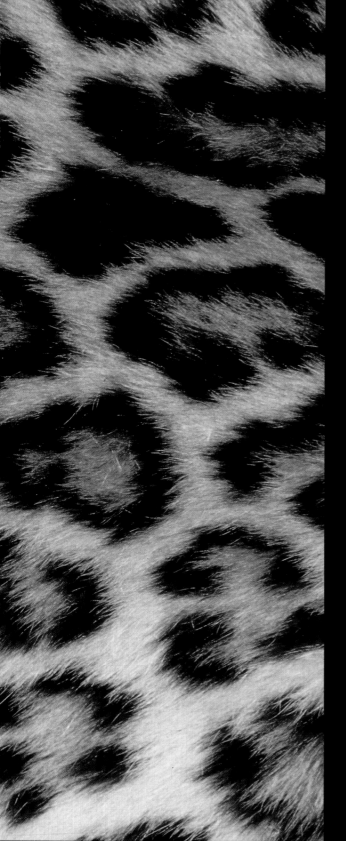

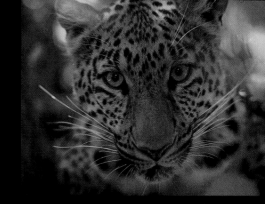

"**R**eckless as

the wounded elephant.

Silent as

a shadow,

with a voice

as soft

as

wild honey."

You knew me

well,

Mr. Rudyard Kipling!

—The Leopard's Song

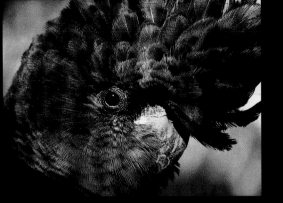

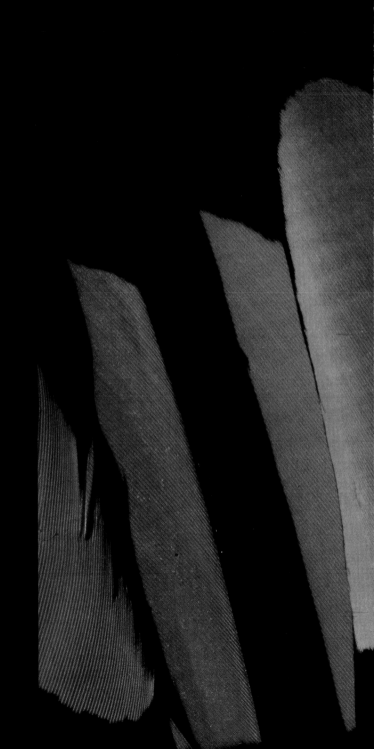

ou sun

ignite

panther blood

on onyx

spilled

or simply

the color

of

my tail.

—Song of the Red-tailed Black Cockatoo

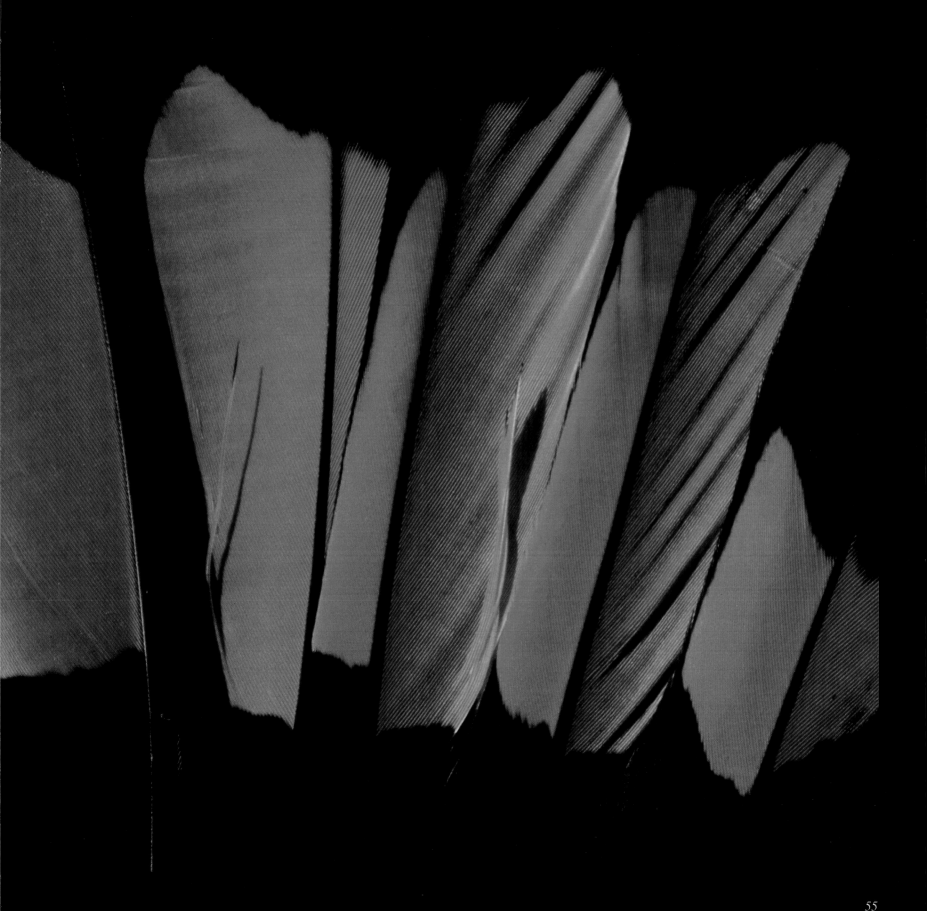

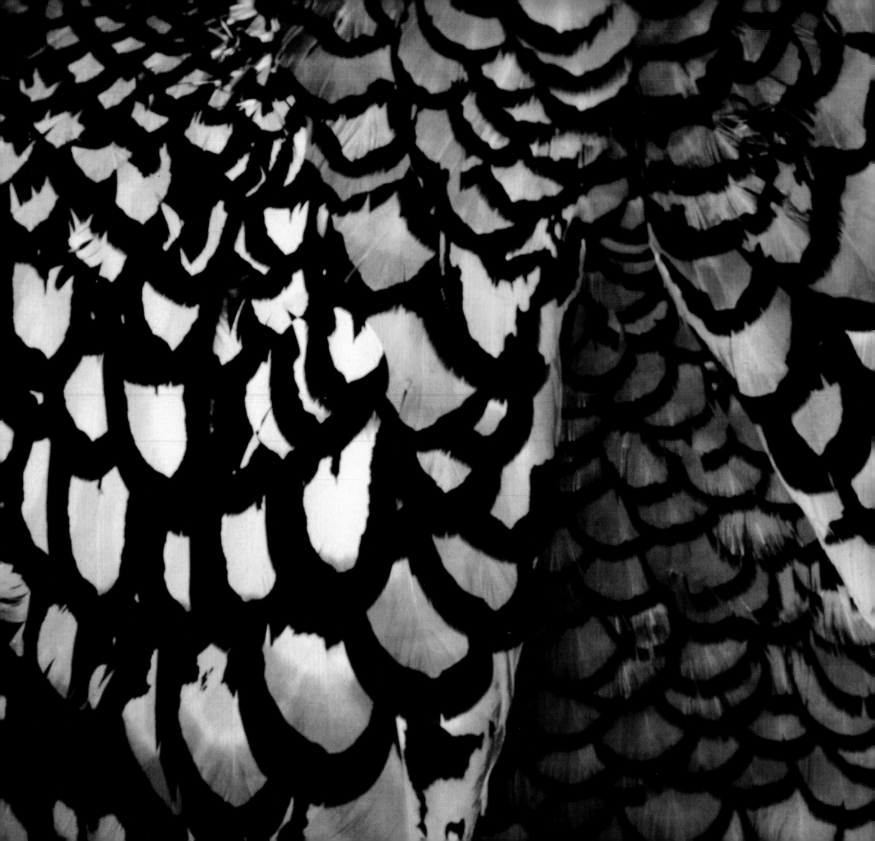

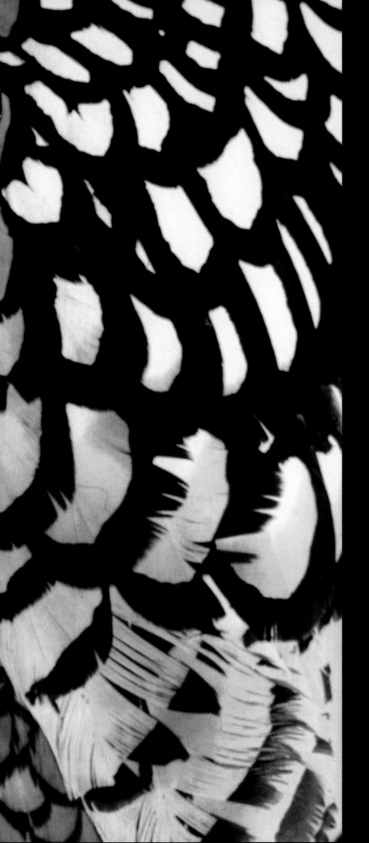

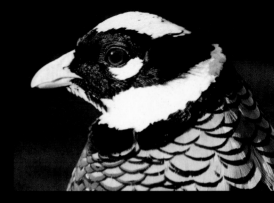

icocheting—

off off off

along along along

above above above

the great wall

my

oriental voice

rakes

the dawn.
—Song of the Reeves's Pheasant

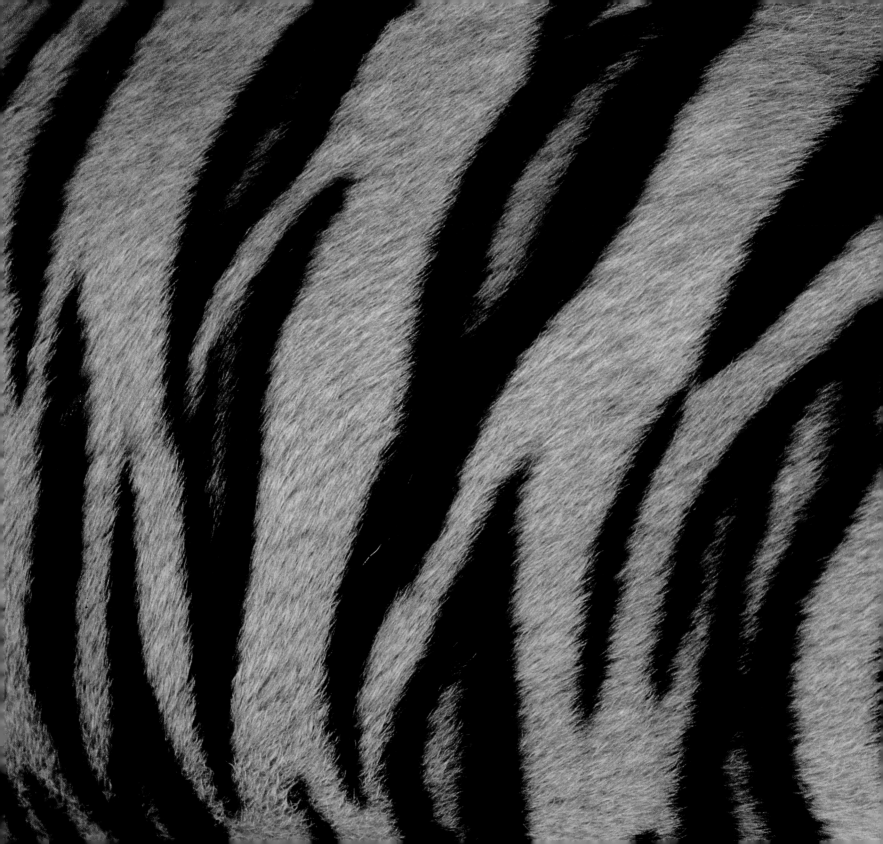

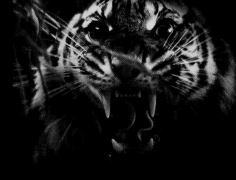

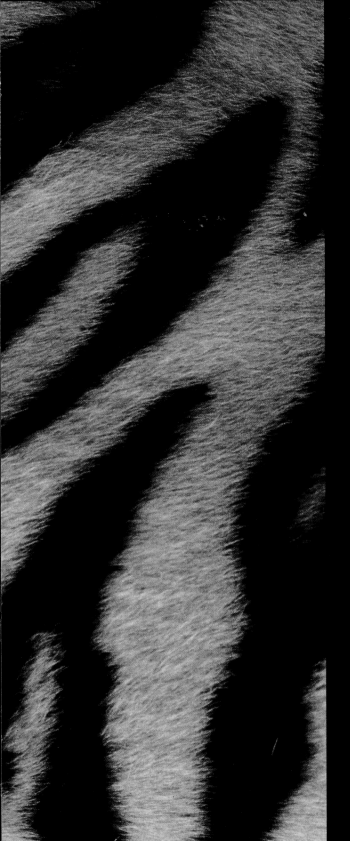

h,

if man doth pay

my weight in

gold

for but a copy

of these stripes

painted cold,

then

how much

for me

alive?
—The Tiger's Song

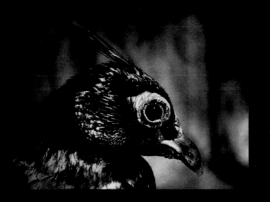

*K*aleidoscope of

Annapurna coral

at break of

day, of

midnight blue of

Katmandu.

There is

in all the world

no iridescence

like

my Himalayan sheen.

—The Impeyan Pheasant's Song

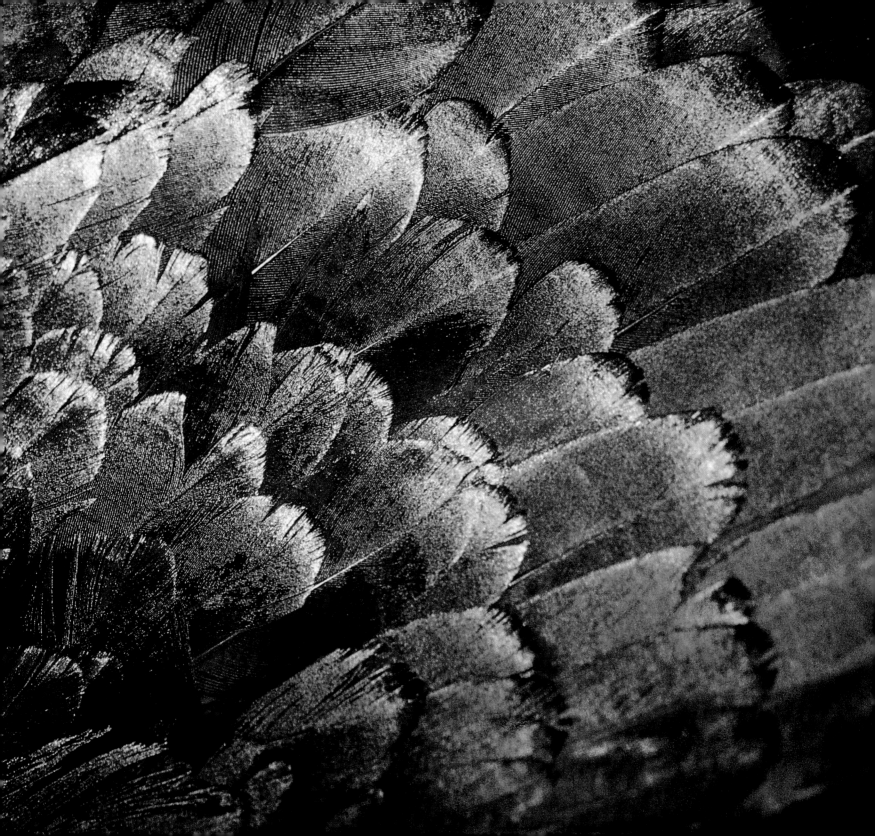

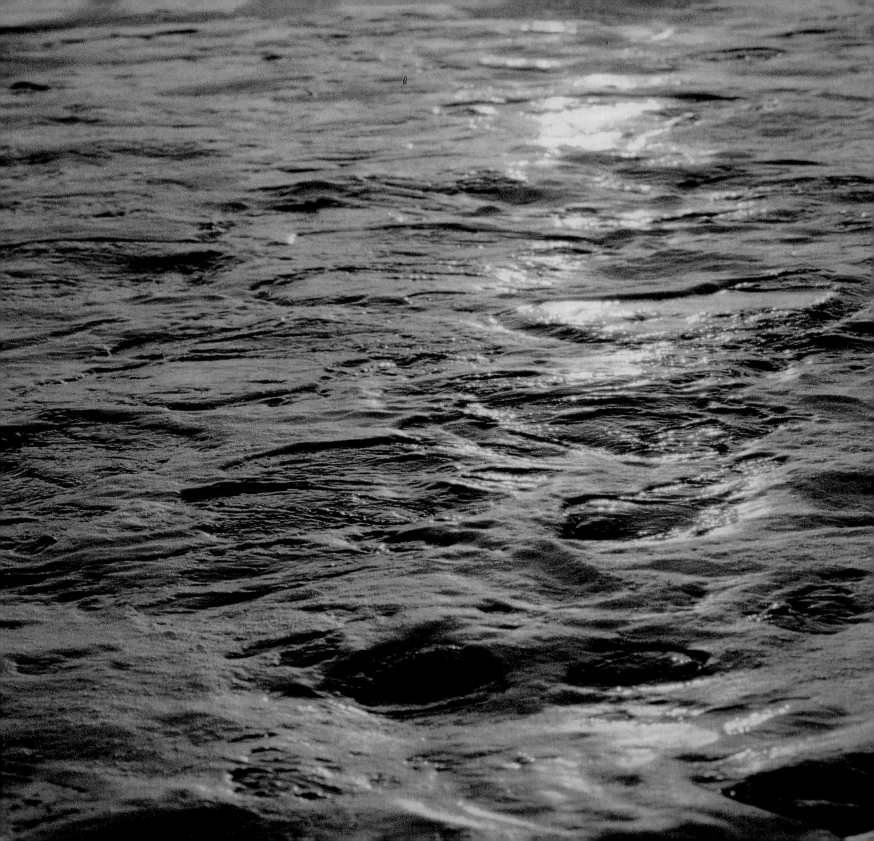

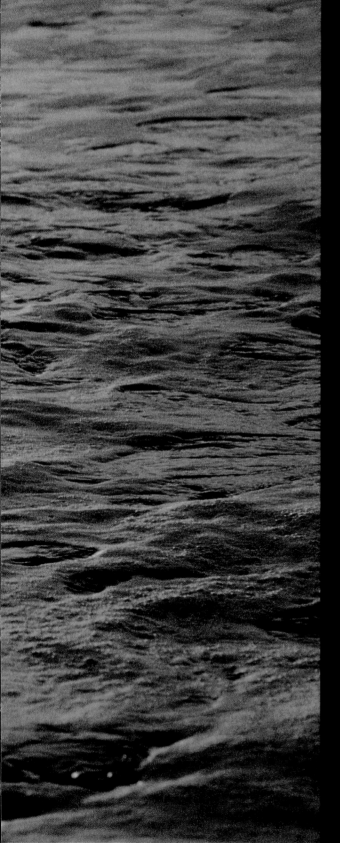

 ntamed,

I sing

in a thousand

tones,

a thousand faint

and

roaring melodies,

while beneath

this luminous mantle

sirens

sway.

—The Sea's Song

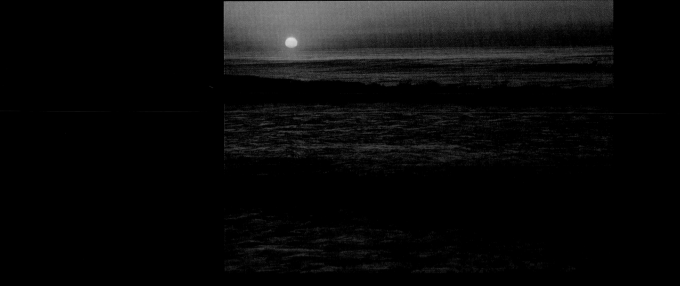

There is a pleasure in the pathless woods,

There is a rapture on the lonely shore,

There is society, where none intrudes,

By the deep sea, and music in its roar:

I love not Man the less, but Nature more.

—Lord Byron

Reflections, Continued, and a Comment on the Images in This Book

(Continued from page 6)

Apart from the butterflies, wild flowers, and images on film that I collected, I began to pick up pieces of stone, wood, and bone. Among those objects, most of which were placed at the foot of a table and canvas washbasin in front of the tent, were two Cape buffalo skulls. One we had found several days after the live beast to which it belonged had been ambushed and pulled down by eight lions near Sekerot's stepmother's hut. It was a handsome skull with wide sweeping horns and in far better shape than the other which Morkau, a favorite friend, had, unsolicited, brought into camp with the hope of pleasing. Instinctively, he seemed to sense that I enjoyed such "odd things," though it appeared certain that he did not know why.

In trying to explain to Morkau (interpreted by Sekerot) my affection for the natural objects that then decorated or littered the camp—depending upon how such things are viewed—I thought of a conversation that *Chicago Tribune* features writer, and my *amiga de confienza*, Mary Daniels, had experienced during an interview with Georgia O'Keeffe in New Mexico:

"When I got up and roamed the plank along the house which holds dozens of bleached animal skulls, pinecones, desert driftwood, and bulging, round rocks, she [O'Keeffe] watched me and smiled: 'You see, I like things that are of no value to anyone else, that no one else wants.'"

Later I read that all Georgia O'Keeffe needed for her art came from nature: sun, sky, mountains, plains, and desert; trees, flowers, plants, and all kinds of growing things; common objects—stones, dead leaves, weathered wood, animals' bones—objects generally not regarded as things of beauty. She once said:

I have always wanted to paint the desert and haven't known how. I always think that I can not stay with it long enough. So I brought home bleached bones as symbols of the desert. To me they are strangely more living than the animals walking around—hair, eyes, and all with tails switching. The bones seem to cut sharply to the center of something that is keenly alive on the desert tho' it is vast and empty and untouchable—and knows no kindness in its beauty . . .

I have picked flowers where I found them. . . . Have picked up seashells and pieces of wood where there were pieces of seashells and pieces of wood I liked. . . . I have used these things to say what is to me the wildness and wonder of the world as I live in it.

If I had had the language to express these ideas to Morkau, it seemed at the time he would have failed to understand, but on the other hand, perhaps he would have.

On one issue my sentiments differ from those of Georgia O'Keeffe, when she said that in bones she found greater expressions of life than in the living animals from which they came. A Cape buffalo skull, with great black twists of horn and textured boss crowning the sharp angles and smooth circles of sun-parched bone, has a certain static, hard, stylized design of powerful aesthetic appeal. These elements are not found in a living animal whose form is softened by hair, an animated personality, and made more difficult to study by movement. Both skull and living animal produce equal magnetism in the fields of my artistic sensitivity.

When the question is proposed, "Do you really love the creations of nature more and those of modern man less?" the answer is found at my ranch house in Spain. Whitewashed interior walls are covered with dozens of objects from different parts of the world, as beautiful to me in their shapes as are the memories they evoke. Abalone shells from California and pieces of river stone gathered in Kenya decorate a rosewood table that was carved in India. Afghan camel bags, African antelope skulls and horns, and a Peruvian toucan fancied into a ceremonial breast covering give color to a column. Maasai shields and spears break the starkness of another wall. Over the fireplace, framed in woodworm-holed Spanish pine, a tapestry of peacock feathers is the background against which metallic-blue morpho butterflies gleam. The only painting displayed in the house represents my parents' homestead on the Wyoming plain. Done by my Uncle Frank, it hangs there more for sentimental reasons than for decorative ones.

Scores of paintings, especially those of the impressionists, do wonderful things to my eyes,

mind, heart, and insides. But few of those canvases would be comfortable in the collection from nature and done by natural (primitive) man that casts purity right down to the marrow in the place I call home. In seldom-opened cabinets in this same house, an original Goya sketch and one by Cocteau rest mostly in darkness together with graphics and paintings done by talented and celebrated painter friends.

Flying back from Africa last September, I thought about the hyped-up art market as the plane passed over a hazy mosaic of cities that appeared more like blight on a lovely piece of fruit than creations of the earth's supposedly most sophisticated beings. To look at, I much prefer the domed Maasai huts of cattle dung which were one with the landscape. Famous paintings that I love, and others that I fail to appreciate or understand, have become little more than gigantic wads of currency in a market where the emphasis is on economics, not on artistic value.

A test I favor for measuring the true intrinsic value of a painting or sketch, or any work of art, is shared with Austrian friend and associate, Rudolf Blanckenstein: If one were walking the street of any flea market in Paris, Madrid, or San Diego, how many unfamiliar, unsigned, affordable paintings would we consider for purchase, if the yardstick for buying were solely based on aesthetic appeal? It is interesting to speculate, in this same situation, how many Pollocks, De Koonings, or Warhols, without signature or sales pitch, though secretly appraised for millions of dollars each by Sotheby's or Christie's, would leave the sidewalk by the end of the day, except in the vendor's truck?

Man thinks nothing of paying millions of dollars for a canvas that few persons are able to understand or appreciate except for its cash value—amounts that if used for conservation, might prevent or forestall the extinction of one of the creatures that dazzles our eyes on these pages. I was told of an American zoo tiger exhibit, before which is posted a small sign that reads:

IF A PAINTING OF A TIGER BY REMBRANDT IS WORTH MILLIONS AND MILLIONS OF DOLLARS, THEN HOW MUCH DO YOU THINK A LIVE TIGER IS WORTH?

Yet the vital message does not seem strong enough. If we lose touch with nature, we lose touch with ourselves. If nature does not survive, neither do we.

As the plane from Kenya neared London, I reflected on the lovely and evocative designs I had days before lived with in nature. Then, taking out pen and paper, I began to list some of the patterns that, over the years, have held most fascination for me. Some were seemingly simple objects that one might see daily. Others were from far-off exotic places, like the flank striping of the okapi, hidden in the rain forests of Zaire. So it was that this little book came into being.

When I began to photograph the creatures that grace these pages, reinforced was the message that nature had not created their colors and designs for art's sake, but rather, in most cases, for survival. In the final section of this book, the subject of each photograph is described, as is, in some cases, nature's supposed use for the portion of it shown in these images.

Nature has invented such a multitude of designs! Some are so complex that man, with a little imagination, can glean from them even our most basic symbols of communication. The illuminated capital letters that decorate this text were searched out by Smithsonian photographer Kjell Sandved—they came from the wings of moths and butterflies. During a twenty-year quest for letters and numerals, Sandved has stalked his subjects in thirty countries on five continents: through the rain forests of New Guinea, on the snowy slopes of the Andes, and over rocky escarpments of Malaysia's Cameron Highlands. So successful has been his lengthy search that he was able to send me four butterfly or moth designs for each of the ten numerals and twenty-six letters of the alphabet.

"Beauty is medicine," writes Mary Daniels, and in today's world the medicine of nature is more needed than ever. Weekly I receive this message in correspondence from readers of my books, the pages of which house almost exclusively animals. The most poignant of these arrived not long ago from a half-German girl who had accompanied her terminally ill American father to the United States. She explained how alone and despondent she had felt watching her father die in a foreign country, concluding, "But instead of turning to suicide or to drugs, I turned the pages of your book." Again, proof of nature's healing power

which, for someone very different from myself, had also provided, though only in book form, the will to live.

The images that appear in this book are unfortunately not true to size. Some human manipulation had to be done to insure that they would fit these pages. The large animal designs would have been even more fragmented had they been reproduced to scale, and those from birds and insects would have appeared too small. Hopefully, however, when printed here, some of them will allow the reader to almost stroke the hair of the real animal.

The task of photographing these creatures was, in some cases, more difficult than I had assumed. Light plays off of hair and feathers in different ways, and unsatisfied after a first attempt, I sometimes had to return to my subjects for a second or even third session.

Thumbing through the pasteup of this book, desire wells in me to return to my camp above Maasai Mara where special friend Sekerot, along with Morkau, Moseka, Lepish, and Sicona sit (with ten hours difference in time) around a fire at dusk, waiting for my "someday" return. Tomorrow, within view of the tent, first light may play on many of the designs that our fingers touch here: leopard, zebra, cheetah, and giraffe.

Yes, I do love nature more.

A COMMENT ON THE IMAGES IN THIS BOOK

The Nautilus, page 8.

Because of its chambered shell, the nautilus is a unique creature in the oceans of today. It is the only chambered mollusk. The primary function of the chambers is for vertical movement in the water. Related to the squid and octopus, the nautilus expends water through a siphon in order to direct its movement. Since the soft part of the nautilus is liquid filled, it has the same pressure as that of the depth at which the animal resides,

which may be down to well over two hundred feet. The chambers of the shell contain gases as well as liquid, which are used as agents of buoyance.

The feeding habits of the nautilus are less well known than those of similar creatures of the deep, but the remains of bottom-living crustaceans have been found in those caught.

Nautiluses are mainly found in the deep waters of temperate and tropic zones.

Temminick's Tragopan, page 10.

Temminick's tragopan are found at altitudes from three to twelve thousand feet in the forests of East to Southeast Asia. Although the tragopan is grouped with the pheasant family, some persons believe that it should be classified as a partridge. What is certain, however, is that this bird has not only spectacular feather designs and colors, but that its courtship display is equally fascinating and distinctive.

My friend Dave Rimlinger, avian expert with the San Diego Wild Animal Park, is one of the few persons fortunate enough to have witnessed this nuptial dance in which the male bird either displays laterally or frontally to the hen. Most fascinating is the frontal display in which the cock hides behind a solid object such as a large rock, peering over the top at the female. He may remain there for some time or may jump out immediately in display, twitching his head vertically, while slowly exposing the brilliant blue throat lappet and expanding his feathered "horns." With tail spread he beats his wings. As "horns" and wings vibrate, orange wing feathers become visible to add

even more color to the display. This is followed by calling and crouching, then rising up again in full display while hissing. What hen could fail to be seduced by this bizarre ritual, which is totally unique among true pheasant and known partridge?

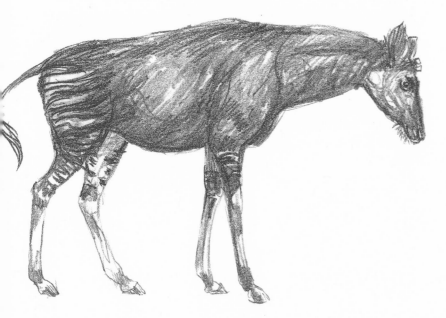

The Okapi, page 12.

Not known to science until 1901, the okapi lives in the dense rain forests of Central Africa where it has been hunted for centuries by pygmies. Okapis, though related to the giraffe, are much shorter, standing about five feet tall at the shoulder. Ten million years ago, Europe and Asia were home to the extinct short-necked giraffe to which the okapi supposedly bears a strong resemblance. Only the male okapi has horns.

When standing still, the okapi's irregular camouflage pattern blends almost perfectly with the forest background. After a six-month gestation, okapis give birth, and the young, like zebras and giraffes, are among the few animals that appear like miniature adults. I have seen these limpid-eyed, seemingly gentle animals become quite aggressive when they feel threatened.

The Abalone, page 14.

Abalone shells, which may grow up to almost a foot in length, have since their discovery been prized for iridescent color. When parasites or particles of gravel enter the shell, the abalone, which is a mollusk, secretes a covering of concentric layers of pearly matter over these irritating foreign bodies—and so it is that abalone pearls are formed.

Abalone are found in the Mediterranean and even along the coast of England; however, it is only in the Pacific Ocean that they grow to great size, especially off the coasts of Australia, New Zealand, Japan, and California. Found on rocks in tide pools, as well as in deep water, they are nocturnal feeders and play a critical role in kelp forest dynamics.

Strictly vegetarians, they do not reach full size until the age of twenty. Now scarce where they were once common, abalone are preyed upon by crabs, fish, octopuses, sea stars, sea otters, and man.

Argus Pheasant, page 16.

The Argus pheasant, which forms a link between peafowl and pheasants, is found in southern Asia. Its name, of course, comes from Argus of a hundred eyes of Greek mythology. The shading of the eyes on this bird's feathers gives them a three-dimensional effect. The cock Argus selects a four- to six-foot area for display during courtship, where he opens his wings, thrusting the tips forward, while displaying the eyes of the feathers as he peers through the wings at the hen. The dance of a

displaying cock is one of the most intensely beautiful and dramatic courtship rituals that I have ever witnessed; and the chance was once mine to view it from a few feet away as a captive-raised bird, imprinted on humans, felt me worthy of his attention. During the mating season, the Argus is very vocal.

Eucalyptus Tree, page 18.

There are over five hundred species of eucalyptus, ranging from ornamentals that grow from six to twenty feet in height to Australia's mountain ash, the world's tallest-growing hardwood tree, which can tower to an excess of three hundred feet.

Perhaps the most widely planted variety outside of Australia is the cladocalyx, which is noted for its spiral grain habit and very hard wood. Eucalyptus shed their bark in different ways; the cladocalyx does so in strips, as illustrated in this photograph. Under stress such as that caused by a drought, this variety is susceptible to the long-horned borer, an insect which will eventually kill the tree. Carried from Australia hidden in timber shipments, the long-horned borer is presently devastating eucalyptus trees and groves in areas of world drought.

Cladocalyx leaves are the only eucalyptus leaves fatal to Koala bears, who refuse to eat them.

Clouded Leopard, page 20.

Weighing about forty-five pounds, the clouded leopard is found in the dense forests of southern Asia, Borneo, and Sumatra. Though classified as a large cat, it is much smaller than the more brightly colored common leopard. The clouded leopard is said to bridge the gap between the large and small cats, as it possesses characteristics of each. Being

arboreal in its native habitat, the clouded leopard is extremely agile and adept at climbing, balancing, hanging by one paw from great heights. From birth it possesses a much greater degree of coordination than other cats do. Its canine teeth are larger in relation to its skull than those of any other cat, and it is thought to be the feline most directly related to the saber-toothed tiger. Because of the length of these canines, its jaws—to accommodate its teeth—open wider than those of other cats. These tusks are highly prized by the natives of Borneo, who use them for decoration and will pay high prices for them. They also use the leopard's pelts for seat mats, and skins were sold in Europe to fashion "booties" to be worn over boots and shoes.

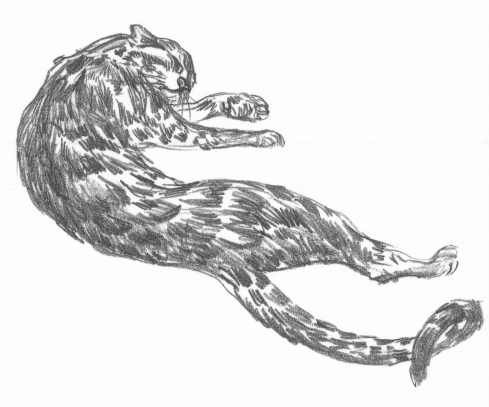

The Macaw, page 22.

There are twenty-two species of macaw (eight of which are extinct) and twenty-one subspecies. Those that appear in this book are the scarlet macaw (page 23) and the military macaw (page 30). In Peru, feathers of these birds were reportedly highly prized for ceremonial costumes by the Incas, who hunted deep into the forest in search of them. The largest of all parrots, macaws live in Central and South America.

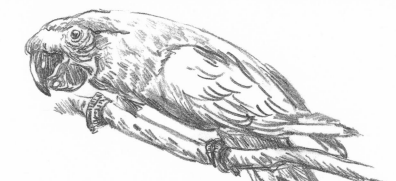

Favorite nesting spots for these birds are in the hollow trunks of trees. Extremely loud and vocal, macaws have now been successfully bred and raised in captivity. The native population, however, is still being gravely depleted by hunters who sell live birds to pet dealers.

One of nature's most supreme pageants is that of a large macaw flock on the wing, rainbowing the air over the tropical treetops.

The Cheetah, page 24.

Claimed as the most doglike of all cats, the cheetah differs from other felines by having non-retractable claws. Faster than any other mammal— at speeds of up to seventy miles an hour—the cheetah preys mostly on small antelope like the Thompson's gazelle. However, it tires quickly and can keep up its great speed for only a short distance. It hunts alone, almost exclusively by day, though it is reported to also hunt by moonlight. The cheetah depends on sight to locate its prey, rather than on scent. Cheetahs often have their kills stolen by lion, leopard, and hyena. Toward man, these gentle cats are not aggressive unless cornered.

Once inhabiting most of southwestern Asia, the cheetah is now found almost entirely in Africa, except for several small populations in Iran. The call of a cheetah sounds very much like the chirp of a bird. As with most of the other animals in this book, the cheetah's spot pattern certainly is of great camouflage value.

Elephant Ear Philodendron, page 26.

Pictured here is the *Philodendron evansi*, which is native to Brazil. This plant is commonly called the elephant-ear philodendron because of the shape and size of its leaves, which grow to five feet in length. The lobes in the leaves are scalloped and ruffled, but not deeply cut. The *Philodendron evansi* can reach a height of eight feet or taller. Seeing hundreds of these immense leaves, moving slightly with the breeze in a tropical rain forest, is indeed a spectacular sight.

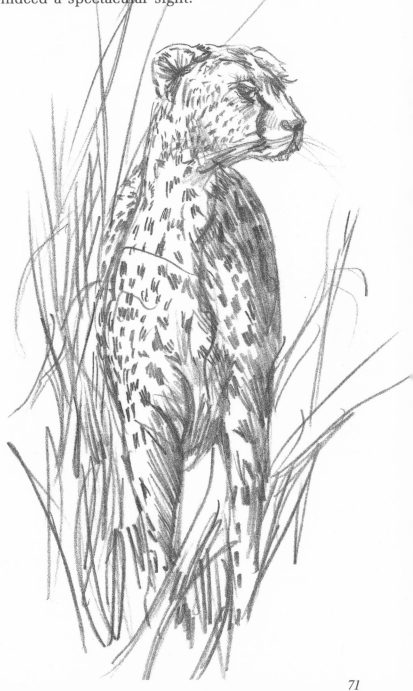

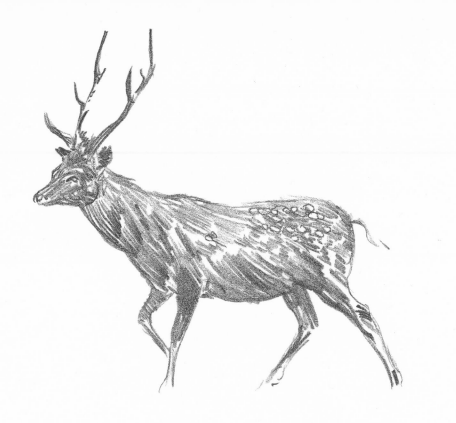

The Sika Deer, page 30.

The Formosan sika deer of Taiwan is one of sixteen races of sambar. Like the fallow deer, the sika does not lose its spots, but sports a white tail instead of a black one. When alarmed, the sika reveals a white patch on the rump. The stag has a call that starts with a modulated whistle and ends in a grunt, which is repeated several times and heard during the September rut. These deer are often seen in large herds and the males battle violently during the mating season. The sika's white spots and black back stripe certainly serve to camouflage the animal in the same manner that the spots of fawns, when they are lying hidden in vegetation, make them almost invisible to the eyes of predators.

The Flamingo, page 28.

In southern Spain where I live, flamingos are depicted in cave paintings that date back to 500 B.C. They are among the oldest birds known to man—and fossilized flamingo remains have been found that are almost fifty thousand years old.

Because of its deep-salmon-to-pinkish plumage, the American or West Indian flamingo is considered the most beautiful, and was the variety photographed for this book. The greater or European flamingo, which can measure as long as fifty inches, is white with a slightly pinkish cast. Flamingos nest on the ground, creating structures of mud, stone, mussels, and grass that can be as high as sixteen inches.

The flamingo's food, which consists of small swimming crustacea, is filtered and sifted from the water by the bird's beak. Flamingos in areas little frequented by humans concentrate so deeply during feeding, that once one of my safari companions plunged into the water and grabbed a bird before it realized what had happened. The surprised bird was then released.

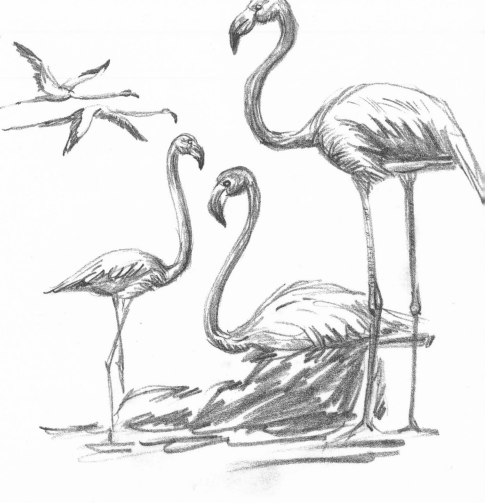

Fall Leaves, page 32.

This fall forest was photographed in Tennessee's Appalachian mountains. It was mid-November, and once the leaves reached their full color, the brilliant spectacle that had lasted less than a week was ended when a storm of heavy rain and wind left branches practically bare.

Biologists believe that one of the main reasons deciduous trees lose their leaves is to prevent too much moisture loss. The process that prepares the leaves of these trees to drop brings about chemical changes that also cause them to change color. In the spring and summer the chlorophyll pigments are in high enough concentrations to hide the always-present yellow and orange pigments in leaves. At this time, some sugar-making trees such as oaks and maples change some of their sugar into bright red pigments, which become even more brilliant with increased chlorophyll loss. These changes are brought on and governed by changes in light, length of night, and, again, by loss of moisture. Among trees that produce leaves of the brightest colors are liquid amber, maple, aspen, poplar, and sycamore.

Zebra, page 34.

There are three varities of zebra, of which two are represented in this book. The flank design on page 35 is that of the Grevy's variety and the portrait on page 34 I took in Kenya of a Burchell's or Plains zebra. The third type is the Hartman's or Mountain zebra, whose stripes are not only broader than those of other zebras, but which also has a distinguishing dewlap, or fold of skin under the throat. It is also the smallest of the zebras.

Grevy's zebras are larger than other species, standing four and a half feet tall at the shoulder. The Plains variety is about six inches shorter. The greater stature of the Grevy's, along with its more complex, refined stripe pattern, make it the handsomest of zebras. In the breeding season, Grevy's stallions become territorial and remain with mares

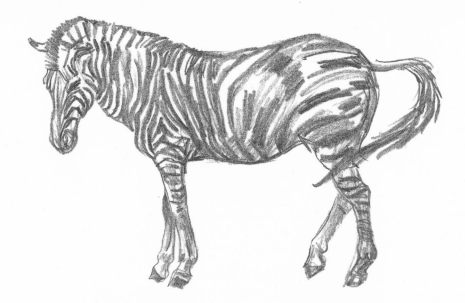

only during that time. The Plains variety, on the other hand, are nonterritorial and may live for years in the same family group.

It has been said that the zebra's stripes are, in the suddenness of a predator attack, designed to form a confusing blur when the herd stampedes. However, in this situation, the lions I watched focused clearly on one animal during their charge and did not take their eyes off of it until it was in their claws or had escaped. Like fingerprints, no two zebras have the same stripe pattern.

African Spurred Tortoise, page 36.

There are over two hundred varieties of turtles and tortoises in the world, and of these, the Spurred is the largest mainland tortoise found in Africa. Though the horny plates on this reptile's forelegs are quite striking, of more interest are the spurs that form part of the shell on either side of the tail. These sharp projections probably help to discourage predators trying to catch a tortoise whose hind legs are pulled in while escaping into its den.

During the hot midday hours, this tortoise spends most of its time in the one- to four-yard burrows that it is very efficient at digging. A large male African Spurred tortoise may measure twenty-four inches in length and weigh up to one hundred eighty pounds. Because of their arid habitats, these creatures may go for years at a time without access to standing water.

Vulturine Guinea Fowl, page 38.

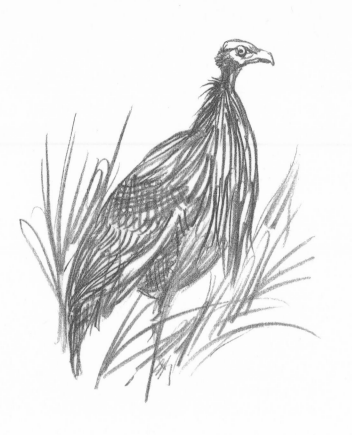

Few African experiences have thrilled this birdwatcher as did the scene of a flock of fifty or more vulturine guinea fowls scratching, searching for food among thorn bushes while Mount Kilimanjaro rose in the background.

The common guinea fowl is the ugly duckling to the vulturine with its impressive white and blue chest feathers and ruby eye. The vulturine is also taller and more slender than are the helmeted and plumed guinea fowl. Vulturines, which spend the day feeding on the ground and resting in trees at night, are famous for their raucous warnings at the first sign of danger.

In Kenya last summer, as the sun dropped toward the horizon, I spent many delightful hours seated on the ground about a mile upstream from camp, watching a flock of guineas, mixed with impala and a troop of baboons, feeding on their way to roost.

Giraffe, page 40.

The giraffe is the tallest of animals, some males reaching a height of seventeen to eighteen feet. Divided into more than a half dozen races, those represented here are the reticulated (portrait) and Rothschild's (spot pattern) varieties.

Found in herds of twelve to twenty individuals, the giraffe can run up to twenty miles per hour. Normally, they amble in a fluid gait in which the legs on the same side of the body move together. Perched on top of a lurching, bumping, speeding Land Rover, this spectacle of giraffe moving alongside, as if in slow motion, was one of the most glorious sights I witnessed in Africa.

The giraffe's prime enemy is the lion, which usually attacks while his prey browses on leaves that are too high for most other animals. The giraffe's only vocalizations are grunts and whistlelike cries. Their distinctive coloring also serves as camouflage, especially during the dry months when the savannah is ocher in color.

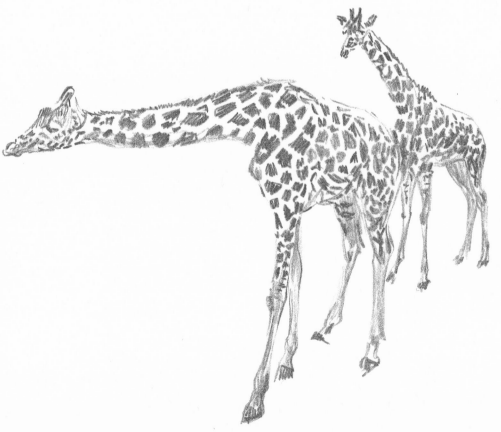

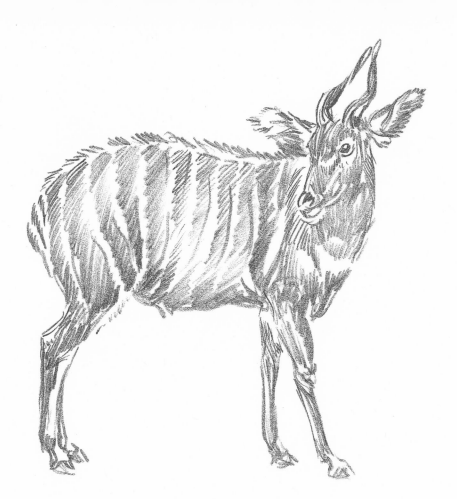

The Peafowl, page 42.

The commonly known blue peacock is the oldest known human-kept ornamental bird. Famous the world over for its beautiful circle of tail feathers, raised and fanned during courtship, wild blue peafowl are found in India and Ceylon. With his twenty tail feathers raised and vibrating, the cock never courts the hen face on, but rapidly turns his back on her as soon as she approaches, which causes her to run around to face him. It has been speculated that the hen isn't as attracted by the beauty of the display as by what such activity might mean. During courtship of other birds, males sometimes feed the females as a means of attraction. This may have once been true with peafowl, and the hen in this case is simply responding to a breed memory. After the cock repeats his approach and retreats several times, the hen finally assumes the mating attitude, after which the male folds his tail feathers and mounts her.

As an exterminator of young cobras, the peafowl enjoys a privileged reputation in India, where it, in turn, is frequently the meal of large cats. The cry of a peacock often warns the jungle that a tiger or leopard is on the prowl.

The Bongo, page 44.

Both sexes of bongo, which live in Central Africa, have lyre-shaped horns with white tips. These horns are used not only as means of defense, but also for digging up tubers or probing natural salt licks and mineral deposits.

Exclusively a forest animal, the bongo population that lives in the Mau district is controlled by the setgot vine (Minulopsis solmsii), which flowers only once every seven years. This vegetation is among the bongo's favorite food, but two-year-old vines are highly toxic, killing not only large numbers of bongos, but also giant forest hogs in a process of natural population control. Calves are striped like their parents, but have lighter, buff-colored coats. The adult male bongo has some black hair which partially covers his sides. The photographs in this book are of a female.

Butterfly, page 46.

Large animals, like the African elephant, are not the only creatures to be threatened by habitat destruction. The existence of many butterflies is also precarious.

Of the world's beautiful insects, few can rival the splendor of the birdwing butterfly (Ornithoptera) of New Guinea, whose underside wings may be seen on page 46. Belonging to the *Papilionidae* family, which contains about seven hundred species spread about the world, females of some of the Ornithoptera sport wingspans of ten inches or more. My friend Bill Toone, curator of birds at the San Diego Wild Animal Park, says that each time he sees one of these dazzling, powerful flyers in the New Guinea jungles, the sight is enough to take his breath away.

Some zoos now feature large, naturally planted butterfly exhibits. Hopefully, the San Diego Wild Animal Park will, before long, be included among them.

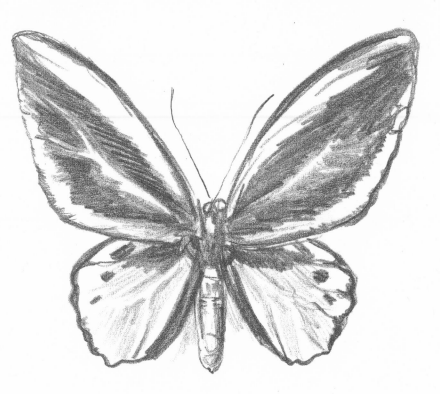

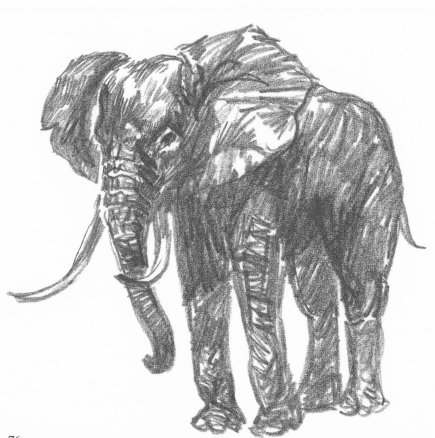

The African Elephant, page 48.

The African elephant is much bigger than the Asian variety, measuring thirteen feet at the shoulder and weighing up to seven and a half tons. The tusks of the African are also much larger, the record one being eleven feet six inches long and weighing 258 pounds.

Despite its great size, an African can move with amazing silence and also at great velocity. I will never forget the first time a bull charged me in Kenya, bearing down at twenty miles an hour, trumpeting with ears extended.

While Asian elephants mostly live in forests, the African variety is more adaptable, also inhabiting wooded savannahs. African elephants need about four hundred forty pounds of vegetation a day. When they drink, if there is sufficient water, they enjoy mud wallowing, which protects their skin against parasites. Africans are also more vocal than the Asian variety, and this, together with their greater height and larger ears, I find makes them aesthetically more attractive than their Asian cousins.

Burmese Python, page 50.

This snake, which can grow to almost thirty feet in length and weigh up to two hundred pounds, lives in a wide range of habitats from northeast India to southern China and south to the Malay peninsula and East Indies. It is the largest of three subspecies of Indian python, and is considered endangered in the wild, being heavily exploited by the exotic-leather trade. Though one of the most colorful of snakes, its protective pattern confuses it with the surroundings in which it lays in wait for prey.

The python's diet consists of rodents, small deer, and forest pigs. Up to one hundred eggs are deposited and incubated by a protective female.

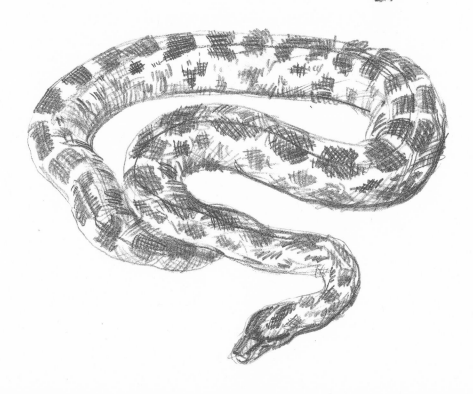

The Leopard, page 52.

The common leopard is found in most of Africa, Asia, and the Indonesian Islands. Unlike tigers and lions, leopards adapt readily to diversified habitats. This flexibility allows them to survive in places near human settlements where other larger cats have disappeared. Adult leopards weigh between 125 and 180 pounds, depending on where they live, as well as on their age and sex.

The black rosettes and spots of the leopard provide marvelous camouflage. Black melanistic forms of this animal, more commonly found in Asia, have rosettes that are faintly visible. The eyes of black leopards are blue, while those of the common variety are green.

Demand for fur, as well as hunting for sport, have greatly depleted the world's leopard population, though because they are such resilient creatures, they still survive in considerable numbers. Last summer in Kenya, each evening a leopard would pass a hundred yards from our tent, voicing his call—similar to the noise of someone sawing wood—which is one of the most attractive of African night sounds.

The Red-Tailed Black Cockatoo, page 54.

These magnificent cockatoos are found in Australia. The male bird is black except for a solid band of brilliant red that crosses the center of his tail feathers. The tail of the female (page 7) is marked with an orange, barred pattern, part of which is edged with yellow.

The cries of these loud birds, in large groups, may be heard in dry woodlands or in trees bordering watercourses. Especially dramatic is to see and hear a flock of them flying on the night of a full moon.

In his display, the male raises his crest and puffs out his cheek feathers while bowing to the hen, at the same time spreading his tail to expose its bright-red band.

The Reeves's Pheasant, page 56.

First reports of the Reeves's pheasant came from Marco Polo upon his return from China. During courtship, the Reeves's whistles repeatedly, displaying to the hen by ruffling his gleaming, golden plumage while he turns one side of his body to her. Continuing to approach sidelong, he then advances in a series of high, kangaroolike leaps. Cocks are polygamous and maintain harems of two or three hens.

The tail of this bird measures five feet in length. Rather than disturb the cock during flight, his long tail plumes serve as both rudder and brake, and are often used for turning sharply. Few sights are more dazzling than that of a sunlit cock Reeves's pheasant on the wing.

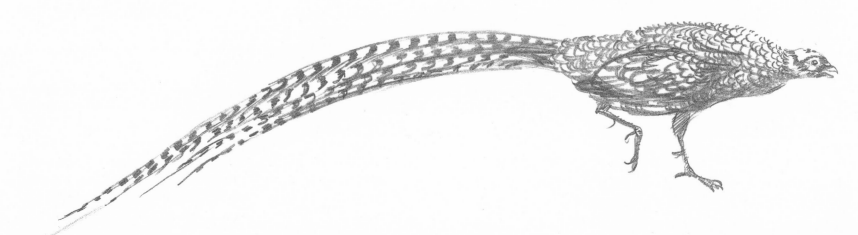

The Tiger, page 58.

The tiger is confined solely to Asia, where it is widely distributed. Animals from one area to another vary considerably in size. Males average four hundred to six hundred pounds, are more than three feet tall at the shoulder, and stretch to a length of thirteen feet including the tail. The largest of tigers is the Manchurian which, like the Siberian tiger, does not have orange and black stripes as bold as those which mark the Bengal and Sumatran cats.

It is estimated that there are about two thousand tigers left in India, human encroachment and agriculture being the major factors in reducing their numbers. In the forest, the tiger lives a solitary life—except for short periods during the breeding season. Though they prey mostly on hoofed animals, tigers sometimes eat peafowl, monkeys, cattle, and now and then, humans.

Because of their striping, tigers are particularly difficult to spot when standing or lying in dry grass. Exceptional in most cats, they are fond of water and often bathe. In this book the small portrait is that of a Sumatran tiger, while the striped pattern belongs to a large Bengal male.

Impeyan Pheasant, page 60.

I don't think any bird can compare in iridescence and color with the Impeyan pheasant, which lives up to an altitude of four thousand feet on the slopes of the Himalayas. Snow and cold in the winter, however, do force the birds to a lower altitude, at which time they are known to covey into flocks of as many as thirty individuals.

The Impeyan's call, which some people feel is reminiscent of a curlew, is heard at the beginning of March and on through the breeding season. During courtship, the male bird struts back and forth in front of the hen, bowing and showing off to best advantage his purple, green, blue, copper, and black metallic feathers, at the same time quivering the brilliant emerald plumes of his crest.

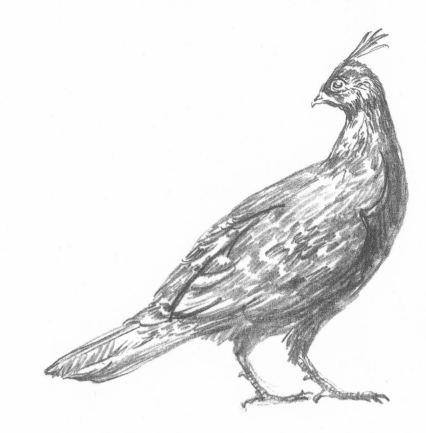

The Sea, page 62.

Never will I tire of standing at tide line, watching the shimmering gold as water retreats from the sand into an immense expanse of violet, blue, copper, silver, gray, and white, which changes by the second as the sun approaches the horizon.

The body of water that makes up the ocean is so immense that if the earth were a smooth sphere with the land planed off to fill the basins, it would be covered with water to a depth of 2,430 meters. The planet, as it is, is covered by 29.2 percent earth and 70.8 percent water. The ocean's greatest depth is reached at 36,200 feet at the Mariana Trench, off the Philippine Islands in the Pacific Ocean. The Pacific, which is shown in the photographs in this book, is larger and deeper than the Atlantic, the Arctic, and the Indian oceans. Apart from controlling the earth's climates, the oceans also supply an immense portion of our food.

ACKNOWLEDGMENTS

First thanks go to my Maasai friend, Sekerot Ole Mpetti, who shared with me his natural way of life last summer in Kenya. The idea for this book came from that splendid experience.

My gratitude is as heartfelt as my admiration is boundless for the Zoological Society of San Diego and their facilities, the San Diego Zoo and the San Diego Wild Animal Park. Deepest appreciation for help with this project goes in particular to Jim Dolan, Larry Killmar, Bill Toone, Rich Massena, and Alan Roocroft (longtime great friends), Randy Rieches, David Rimlinger, Mike Mace, Andy Blue, Greg Sorini, Sunni Black, Judi Myers, Terri Shuerman, Mike Bates, Mark Huston, Georgeanne Irvine, Chris Peterson, Wayne Schulenburg, Barbara McIlraith, Susan Schafer, Dan Simpson, Jaime Páramo, Charlie Henderson, Alison Wood, Kathy Marmack, Heidi Ensley, Carlee Robinson, and Mark Freeland.

Year after year Joan Embery and her husband, Duane Pillsbury, have generously given me help on every new project, and this year was no exception.

From the New York Zoological Society, I thank Rosanne Thiemann for her assistance.

To my friend Ron Whitfield, I again send un abrazo for his continued help and interest in my books.

Al Hinkle also has my gratitude for the time he gave to this effort.

David Kader again proved to be both trusty amigo and field assistant as he accompanied me during much of the photography of the creatures on these pages.

Good fortune also allowed me to count on the fine ear and advice of my friend Mary Daniels.

Rick Fabares, close friend and artist, again lent his creative expertise and talent to my images. Award Prints and Mike Scanlon also were once more helpful with the final color transparencies.

For developing this film I would like to thank Chromacolor and the people there, especially Jerry Dean, Mike Uriell, and John Brehmer.

Deepest thanks go to Smithsonian photographer Kjell Sandved for providing his marvelous butterfly alphabet, which does much to enrich these pages.

Barbara Chance has my deepest gratitude for her help with the book's design.

John Fulton I thank for his excellent drawings.

For more than twenty years I have enjoyed the full support of my publishers, William Morrow and Company, and there I wish to thank Larry Hughes, Al Marchioni, Lela Rolontz, and especially my editor, Andy Ambraziejus, for his continued good advice, concern, and belief.

With this work, Gloria Loomis, my agent, again provided the guidance and friendship to see me through yet another project.

In Europe I thank my associate Rudolf Blanckenstein for his continued enthusiasm. For keeping things going in Spain, I have counted on my friend José Franco. For taking care of me during much of this book, I thank my brother, Ron, and sister-in-law, Gale.

The profoundest of thanks go to all the men and women who dedicate their lives to wildlife conservation, ensuring that every piece of living art that appears on these pages will survive in its natural habitat and not, sadly, only in books like this.